♥ Love Sick

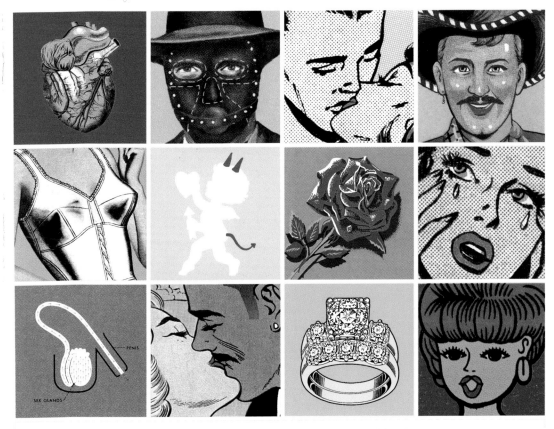

A Smoldering Look at Love, Lust, and Marriage

Charles S. Anderson Design Company

Text by Michael J. Nelson

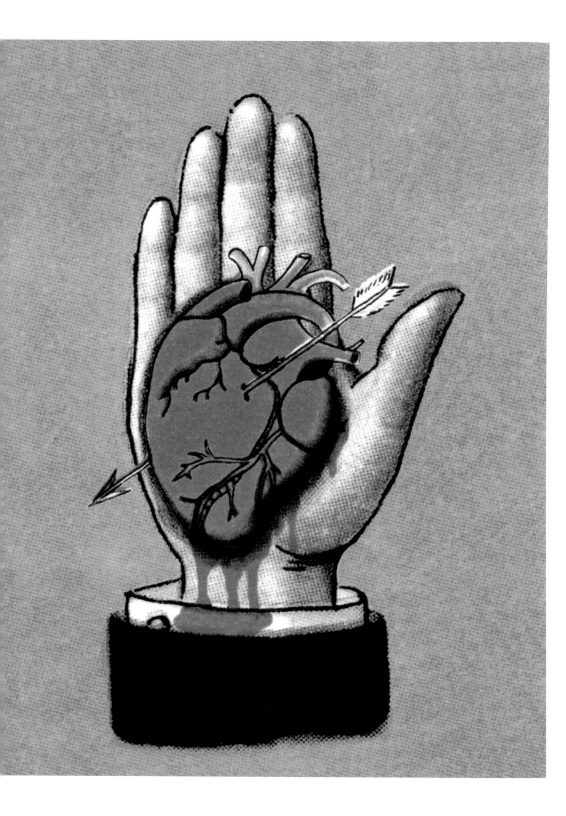

Pop ink

Love Sick

A Smoldering Look at Love, Lust, and Marriage

Love. As the chief motivator of human behavior, it is the undisputed king of emotion. It towers over lesser feelings, such as pity, or that sad-ass little emotion we call joy. In fact, if Love and Joy were in a wrestling tournament, it wouldn't even be close. Love would execute a perfect one-leg takedown followed by a step-over double arm bar for a quick pin inside of twenty seconds. Sure, Joy would shake hands afterward and maybe even force a little, "Nice match," but it would be clear that he was completely shamed and would have to drive home alone in disgraced silence. As for Pity, or Stunned Surprise? Please, they're not even fit to scrub Love's toilet.

Throughout history, the ephemeral power of love has inspired the world's greatest artists: Alessandro Boticelli, William Shakespeare, Emily Dickinson, Edgar Allen Poe, and of course, Prince, who wrote, "Ever since I met you baby, I been wantin' to lay you down. But it's so hard, baby,

when you're a river . . . Falling, falling, falling in love." He went on to eloquently express erotic longing in his immortal "Soft and Wet," saying, "Hey, lover, I got a sugarcane that I want to lose in you." These epic depictions of man's deepest desires are remarkable, especially coming from one who stands only three feet, eight inches in his high-heeled leopard-skin boots. Yet as this pan-like leprechaun of a man humps the stage with such authentic fervor, we are drawn into his expressions of love, and we, too, yearn for a quiet place to hump our own stage. Such is his genius.

As grand and glorious as love is, it is not without its perils. Anyone who has felt the cruel pangs of rejection knows that love is best approached cautiously, as one would approach an angry, cornered brush-tailed possum. Yes, before throwing yourself into a relationship, it's wise to buy a sturdy pair of leather gloves and to be extra careful of love's front claws and rows of needle-sharp teeth. If possible, use a partner to distract love and very quickly move in behind it, grasp its prehensile tail (carefully!), pop it into a canvas bag, and, quick as you can, yank closed the drawstring—metaphorically speaking.

Perhaps worse than the pain of rejection is the emotional death one suffers when good love goes bad. Sometimes, despite their best efforts, a couple

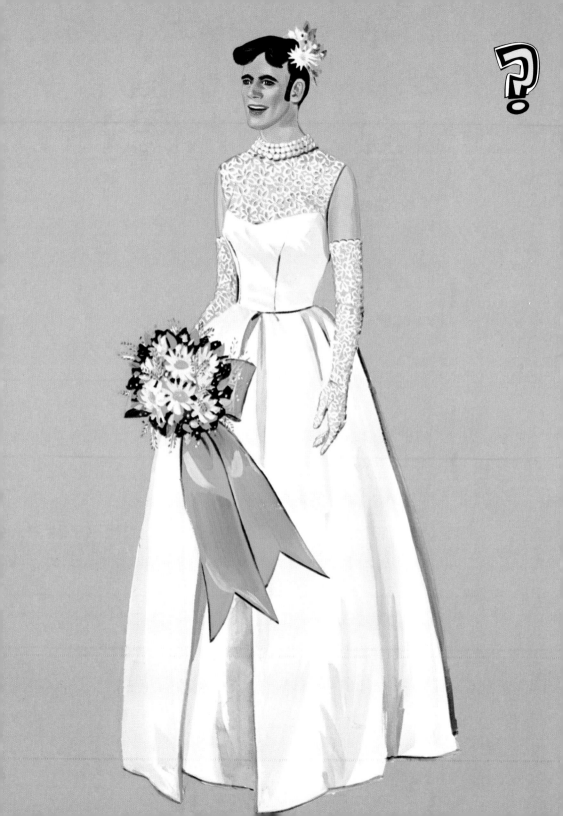

simply grows apart. One may suddenly discover an enthusiastic awakening of the faith of his childhood, while the other will satisfy a long-suppressed urge to visit an old boyfriend, Tom, at the Sunset Motel on East 3rd Street from four to six every Tuesday when she is supposed to be at her knitting class. And because he simply can't share this interest, no matter how hard he tries, the two must part.

Rather than risk the hurt, many choose to avoid the cornered brush-tailed possum of love altogether, and remain single for the entirety of their lives. We call these people "bachelors," "bachelorettes," "spinsters," or "cat owners." Though they never experience the giddy highs of love, they also never face its cruel lows. When they find, for the hundredth time, a dry, brown, half-eaten can of tuna on the counter, they feel little of the helpless rage and betrayal that their married neighbors feel, for there is a better than average chance that it was they who left it there.

Love Sick is a pictorial exploration of the many facets of love: dating, marriage, heartbreak, sex, and strange, thin men in odd shorts with funny socks. So grab a cozy spot by the fire, snuggle up with the one you love (disregard this part if there isn't one), and see if either of you recognizes yourself in *Love Sick*.

HEART

The heart is an immensely complicated muscle, comprised of a myriad of interconnected parts, each highly specialized and intricately tuned, a precision instrument of both strength and delicacy–kind of like a toaster. Though not one of those high-buck German toasters that monitor the progress of browning. Those things are amazing! No, the heart is more like a mid-level toaster from a decent warehouse store: utilitarian and durable. But not that durable, as it can be pretty thoroughly trashed if you eat a couple of Italian sausages and too many pork chops. Do that and you might be shopping for a new heart.

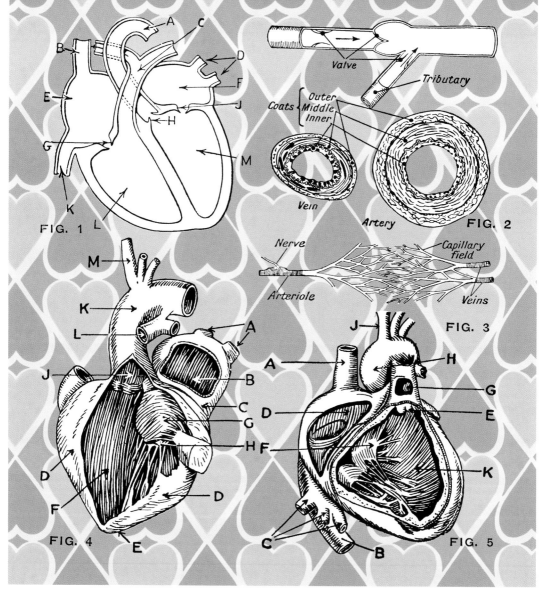

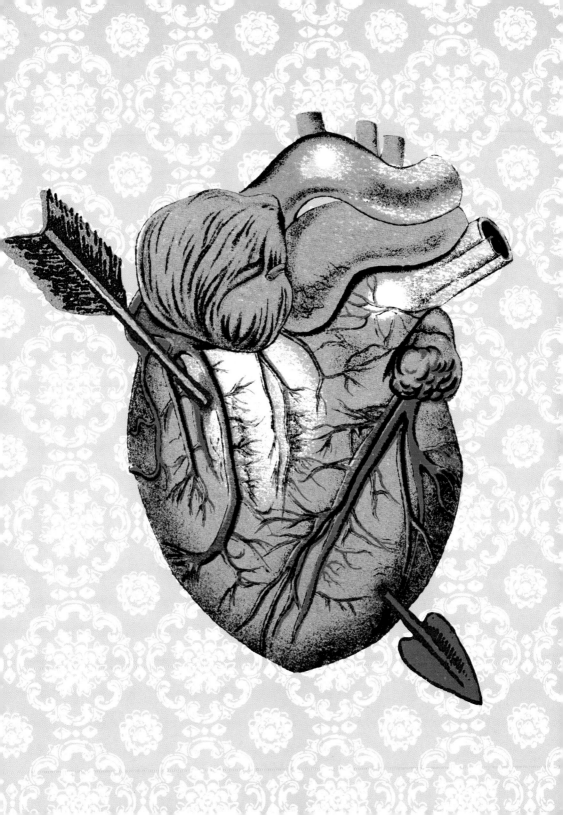

Queen

As the great philosopher Juice Newton once observed: "Playin' with the queen of hearts. Knowin' it ain't really smart. Joker ain't the only fool who'll do anything for you." In fact, on AM radio in the early '80s, she observed it some 57 trillion times until many begged her to stop.

Nothing quite says "I love you" like a heart-shaped box of chocolates . . . purchased at a drugstore on the way home from work for $2.99 along with a package of combs, some generic dandruff shampoo, and a tube of jock itch cream.

Chocolate contains a chemical called anandamide, responsible for the mild euphoria "chocoholics" experience after eating it. One side effect of adandamide, as the fellow in the illustration knows all too well, is the tendency to acquire a strong resemblance to hamburger mascot Big Boy, for the gaps in your teeth to grow abnormally large, and to smile maniacally and homicidally at all times.

Love

Doctors recommend that you tattoo an exact replica of your cardio system onto your chest so that, in the event of surgery, they don't have to paw around your innards looking for the right part.

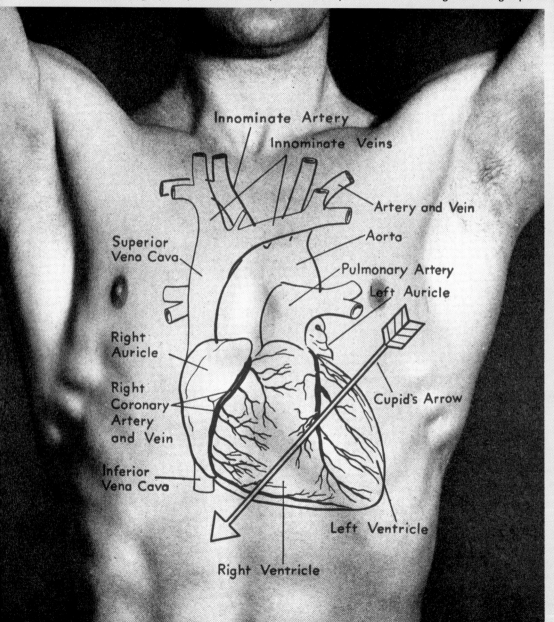

Innominate Artery

Innominate Veins

Artery and Vein

Superior Vena Cava

Aorta

Pulmonary Artery

Left Auricle

Right Auricle

Right Coronary Artery and Vein

Cupid's Arrow

Inferior Vena Cava

Left Ventricle

Right Ventricle

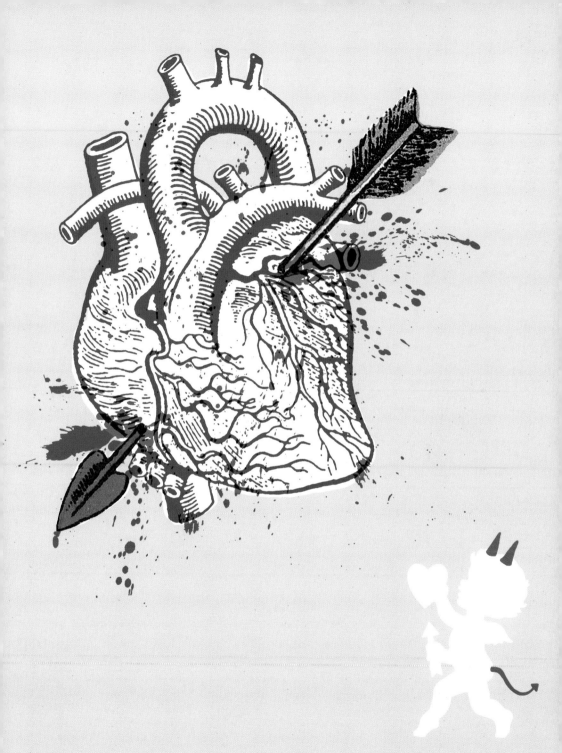

Beware—or Cupid, the chubby, out-of-shape god of love in the infrequently changed diaper, may strafe your home and fire a broadhead-tipped arrow into your left ventricle. Causing you to love.

In ancient times, the heart was known as the seat of all reason. To modern man it is known as the seat of all love, as well as being the seat of all coronary artery disease, tachyarrhythmia,

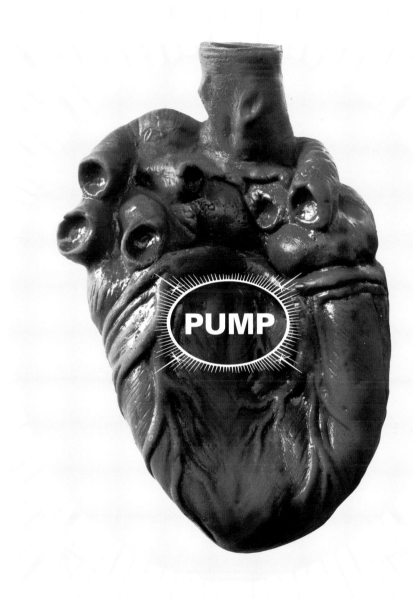

aortic regurgitation, pericarditis, bundle branch block, cardiomyopathy, congestive heart failure, J-curve phenomenon, mitral valve prolapse, atrial fibrillation, and Ischemic heart disease.

BRIBERY

Roses are without a doubt the quintessential expression of love (next to saucy underpants and costume lingerie) and every color of rose has a symbolism all its own. A red rose symbolizes love, respect, and courage, while a withered black rose signals to the recipient that a dinner at Taco John's followed by a ride in a 1980 Dodge Colt and an invitation to "throw down on the Murph-meister" does not qualify as romance.

1

2

5

6

DOZEN

9

10

There is no substitute for a dozen real roses, but be aware they are susceptible to beetles and leaf blight. Just to be safe, buy your love a dozen shrink-wrapped "panty roses" instead.

"My love is like a red, red rose," said the poet. When comparing your own love to vegetation, avoid common buckthorn, broadleaf weeds, and the stinking corpse flower.

Men are often falsely accused of "bribing" their women with flowers, when in fact all they are doing is trying to buy their mate's affection and to detract from otherwise shoddy behavior.

Rose

Though roses themselves are quite romantic, Pete Rose is, in fact, the least romantic thing on the face of the earth. Do not present your love with a disgraced second baseman with a bowl cut and a gap in his teeth the size of a buffalo nickel.

Rose

Every rose has its thorn, it is said. But since it was said by the L.A. hair band Poison, who also made the easily disprovable claim that "Every cowboy sings a sad, sad song," you should approach it with a great deal of skepticism.

HUMAN ANATOMY

For many lovers, there is usually a natural progression of physical affection that begins with hand-holding, moves on to chaste kisses and light hugging, then to more passionate kisses, back to hand-holding–with minor regressions into icy standoffishness–and eventually on to more serious physical intimacy. In order that this may go well, with as little weeping as possible, it's helpful to have a basic understanding of human anatomy. According to the latest available sex research, men's genitalia consist of "units" or "things," while women's consist of something entirely different that is, as of yet, unidentified. This very basic primer should serve you well into your forties, when more up-to-date information may be available.

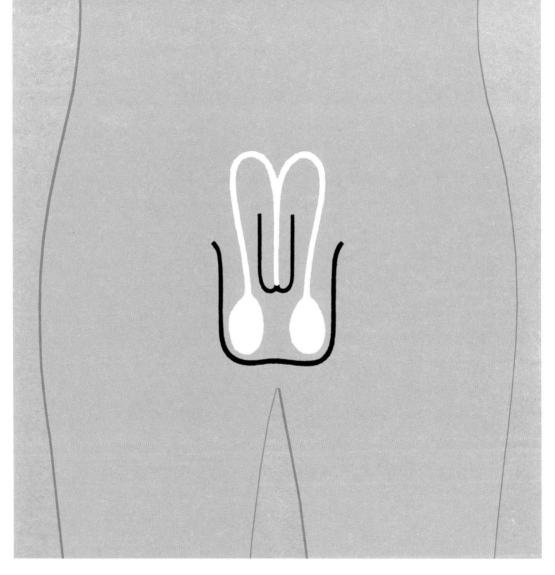

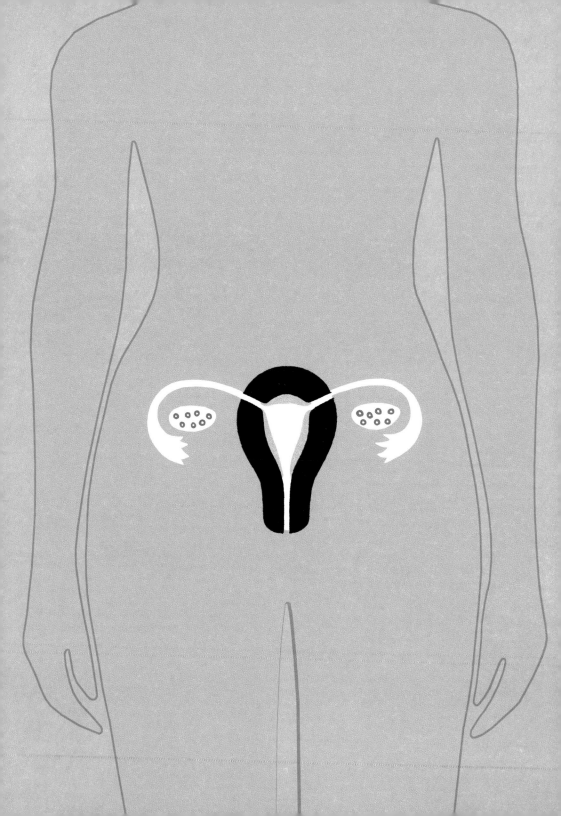

Some say that in order to be attractive to the opposite sex, it's important to keep fit and trim, while others say beauty is on the inside. To see which theory holds, why not subsist for a whole year on nothing but sports shakes, scotch eggs, and curly fries, until there is at minimum a four-inch

layer of fat on every part of your body, including the knees and the head? Then go out on the dating scene, approach a potential mate and say, "Go ahead, take a great big gander at my inner beauty, sweet cheeks!" When you're done, please give us all a full report on what happens.

GIANT

Though genital hypnosis has been exposed as a fraud, many women may try to mesmerize your tallywhacker. If you feel mild heat down under, yours may be under attack.

Love means giving all to your mate, not only your heart, your soul, and a lifelong commitment, but also a giant, square-cut diamond ring. You can try to get away with example number two, but that will seriously endanger your chances of, well, refer to the diagram above.

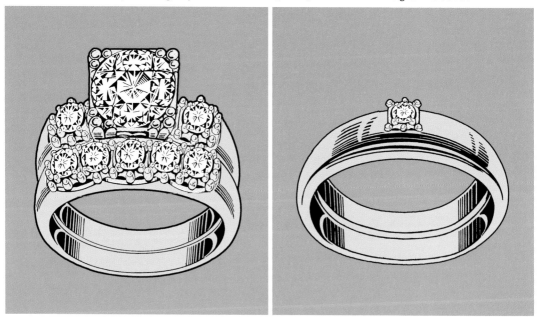

Though possessing large feet may have certain advantages, there's a downside, too. Size fourteen shoes and above have to be specially ordered from stores with names like "Walking Tall Footware," or "Sasquatch Shoes." And when barefoot, you risk shouts of "Hey, Frodo, shave those things."

Remind you of anything? That's right, it's a reminder that to stay in good health, you should always eat your fruits and vegetables, though preferably varieties that don't wink at you.

Don't get any ideas; this is Sky Scrapery, the smiling skyscraper mascot, and his two little friends, Scooter and Woody, and they are here to remind you to, um, enjoy skyscrapers.

SWINGERS

Men, when you truly love a woman and she truly loves you, you will want to give her the gift of your genetic material. (For instructions on how to do it, refer to the below diagram). The kind of child you produce will be hugely influenced by your unique genetic material, but even more so by the name you give him. Take little Garland over there–because his parents tried to get creative, he has zero chance of any happiness in his life and will be beaten regularly like a gong. Much better, more solid name choices are Oak, Gareth, Festus, Kai, Terrence-Philbert, and Dudley.

- - - - PENIS

SEX GLANDS

BACHELORS

In America today there are more bachelors, proportionally, than there have been at any other time in history. The single greatest cause for continued bachelorhood is the staggeringly bad choice of eyewear. Take the fellow below—"I want to impress the ladies and I'm certain wearing goggles is the way to do it, but is there any chance you could custom make some opaque lenses with hearts on them? There is? Oh, thank you! I shall be married by week's end!" Sadly, it did not, nor will it ever, come to pass.

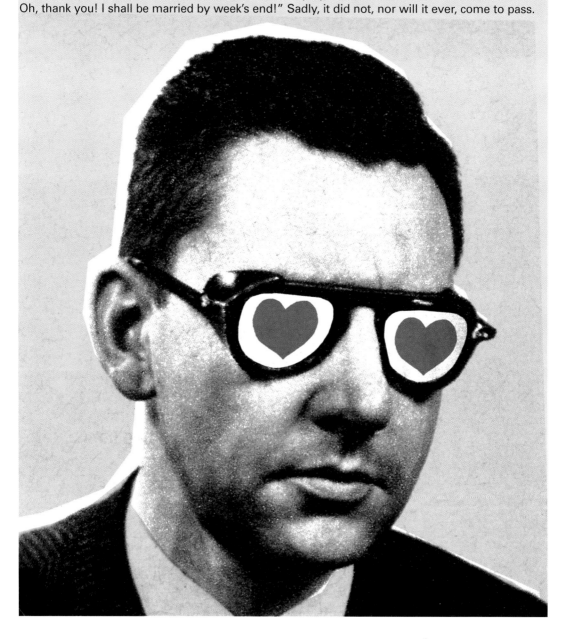

This guy's headband is badly placed. Consequently, he shall never find love.

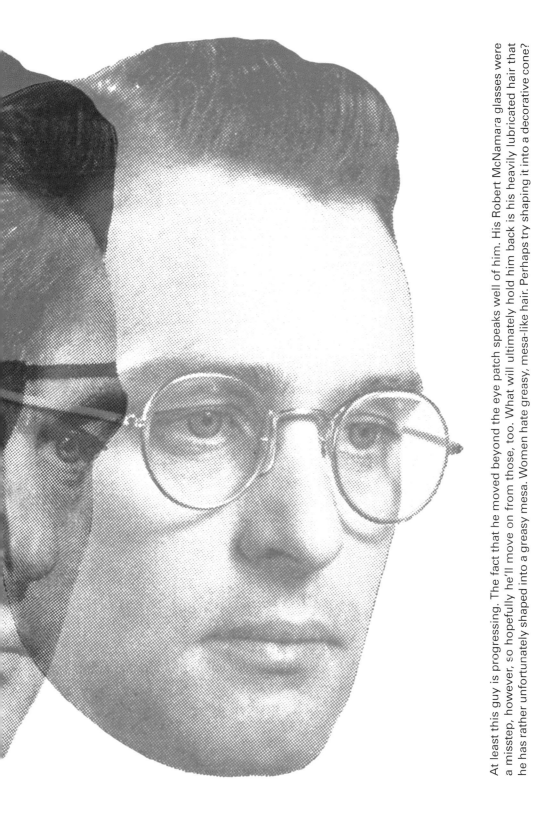

At least this guy is progressing. The fact that he moved beyond the eye patch speaks well of him. His Robert McNamara glasses were a misstep, however, so hopefully he'll move on from those, too. What will ultimately hold him back is his heavily lubricated hair that he has rather unfortunately shaped into a greasy mesa, mesa-like hair. Women hate greasy, mesa-like hair. Perhaps try shaping it into a decorative cone?

In poll after poll, it has been shown that women are relatively unconcerned about male hair loss, while the men themselves will do nearly anything to reverse it. This includes visits to strip mall

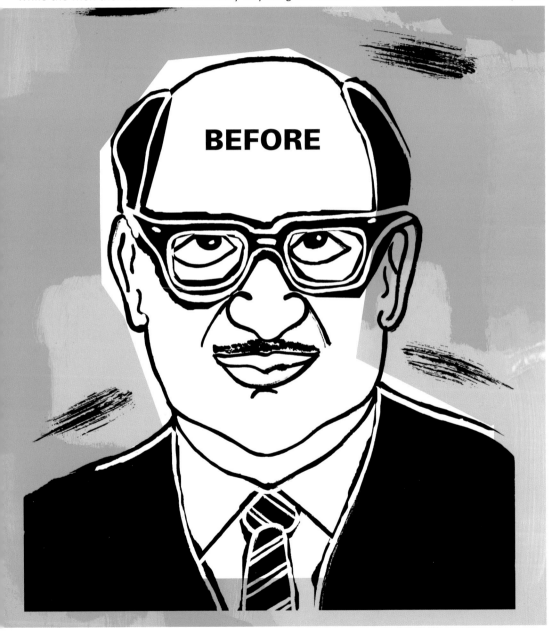

doctors who use a hole punch to remove bits of scalp and implant them elsewhere on the head–hoping, I guess, that the pain and blood loss will convince men that baldness isn't that big a deal.

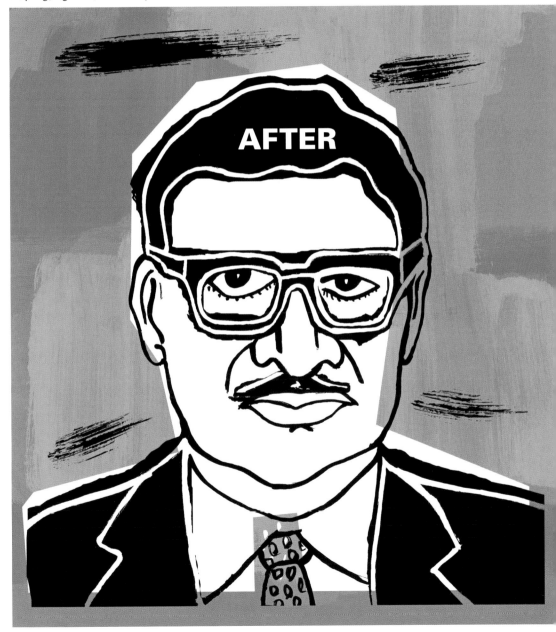

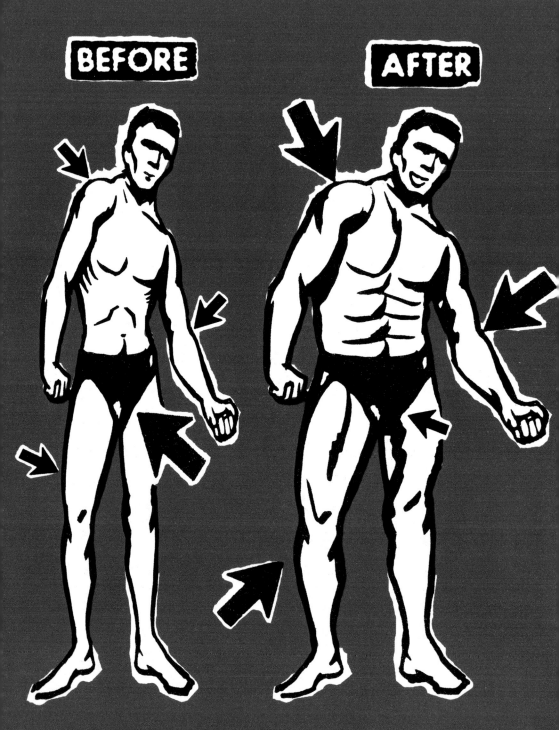

Do you happen to be a 98-pound weakling, constantly getting sand kicked in your face? Why not get a nice pair of shop goggles, or try going to another beach? Or you could start an excessive workout regimen, buy a tiny Speedo, and fight back, I suppose.

The Chest Heaver

The Cheek Builder

The Bait Spinner

The Reverse Pit Stretcher

The Numb-Chucker

The Fabulous Lunge

Ass Taffy Pull

Extreme Sock Pull-Up

Crotch Launcher

One-Handed Chick-Lifter

The Two-Guy Chawmp

The Bus-Stop Bench Press

Quadruple Man Grab

The Dental Dam

Four Person Lap Jump

When working out, for safety's sake, always wear a clingy bikini bottom and thigh-high, lace-up leather boots. (In extreme circumstances, feel free to substitute either a dance belt and a pair of chef's clogs, logging boots and no pants, or a banana warmer and sandals.)

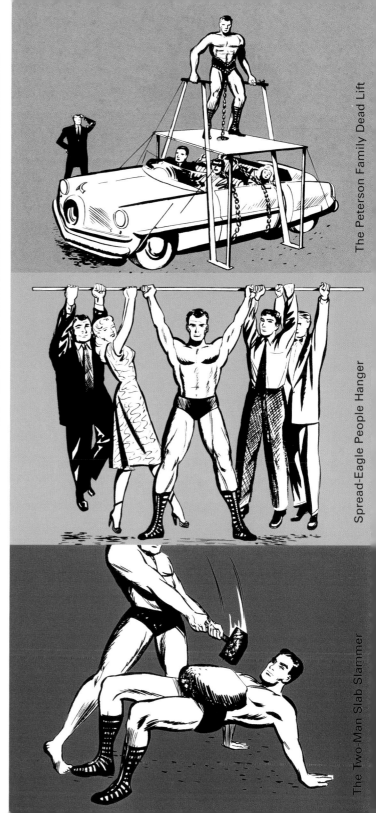

The Peterson Family Dead Lift

Spread-Eagle People Hanger

The Two-Man Slab Slammer

For most men, hygiene is not as high on the priority list as is, say, throwing peanuts at the cat, while women generally try to avoid letting their homes become foul and squalid. This difference can cause tension between couples, and compromise is needed. Guys, try running a rag over

HIS

something now and again, or if something dies in your home and begins to decay, you might want to take steps to remove it. And women, if your beef and bean burrito blows up in the microwave, no need to clean up right away. Give it three weeks or so. It'll still be there.

HERS

BACHELORETTES

Women know that in order to snare a man, it's important to have fabulous hair, for that is among the first twenty things that a man will notice about a woman. Styling one's hair in a desirable manner is not difficult. Simply wet hair, massage in a small amount of ginger and balsam scalp treatment. Wait five minutes. Rinse. Shampoo with a revitalizing botanical shampoo, rinse, repeat, then condition with flax seed and jojoba moisturizing conditioner, then use a quality finishing rinse, one with almond and birch leaf. Rinse. Treat hair with lemongrass detangling spray. Put hair up in towel. Leave for six hours. Remove towel, throw on a wig, and you're good to go.

Beauty

Though often attributed to men, the tendency to loll about the house while starkers is enjoyed by women as well. This fetching young thing just finished up a giant economy bag of Bugles

Shapely

and is settling in to watch a *Hogan's Heroes* marathon. When that's done, she might throw on a pair of boxer shorts and take out the garbage before going online to play a few hours of Doom 3.

She's either thinking something naughty–or recalling that bust where they had to shoot the perp.

It's all well and good when lingerie is saucy, naughty, and beguiling. But let us never forget

GIRLS!

that its true purpose is to lift, boost, separate, and, most importantly, prevent chafing.

titePLASTIC

Far from being a source of shame, the naked human form is a miracle, God's handiwork, an achievement of unsurpassed beauty. Naked women, that is. Naked men are a nightmare: hirsute, lumpy masses of flesh seemingly without form or purpose. And shame? Good heavens, when a man gets naked, there's heaps of it. Think about it–have you ever been comfortable in the presence of a naked man? If you are a man, have you ever been comfortable being naked? Thank God for pants.

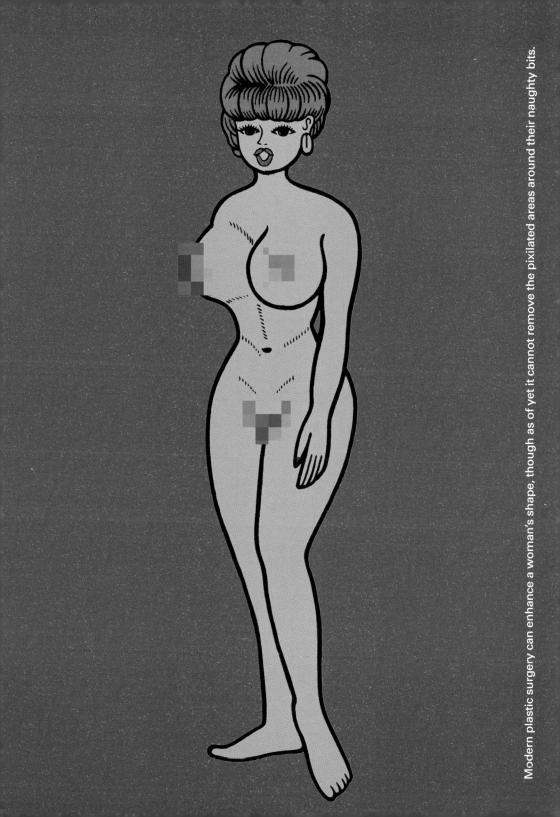

Modern plastic surgery can enhance a woman's shape, though as of yet it cannot remove the pixilated areas around their naughty bits.

Foundation garments form the very bedrock of a woman's wardrobe. Why, they are the very . . .

foundation. Though a few of these seem like they'd work as the foundation of a suspension bridge.

The secret's out: Men, for whatever reason, like looking at pictures of naked women. God help them, men even like looking at the shadows of naked women on the mud flaps of eighteen-wheelers.

PiN-UP

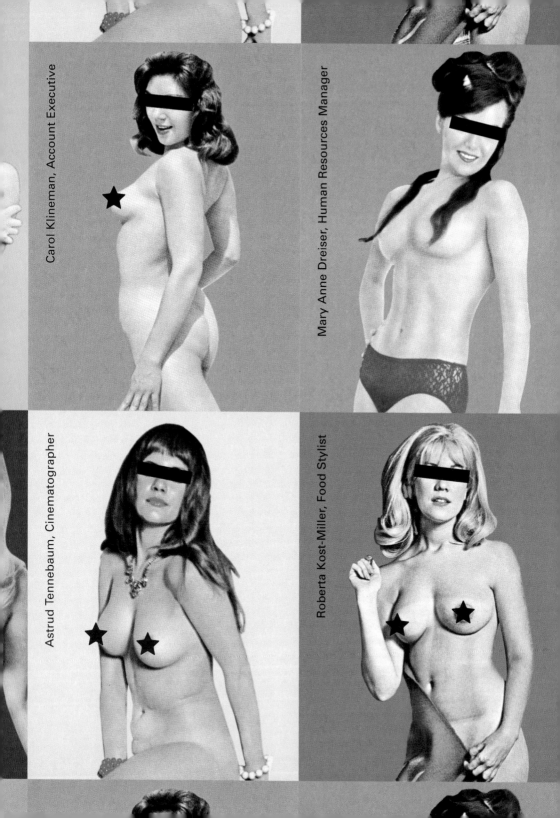

Carol Klineman, Account Executive

Mary Anne Dreiser, Human Resources Manager

Astrud Tennebaum, Cinematographer

Roberta Kost-Miller, Food Stylist

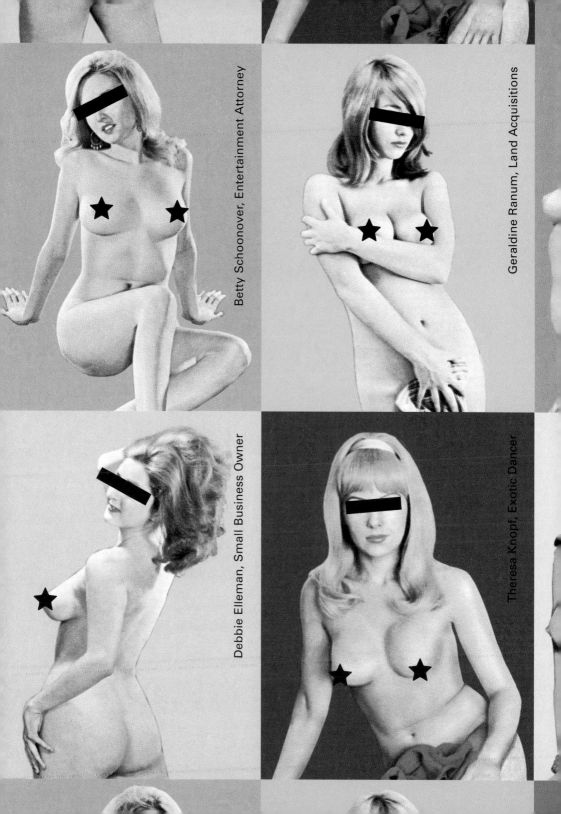

PERSONALS

Finding love is not always a simple or organic process. It's not as easy as going to the bus station, finding someone who looks suitable, and saying, "Love me, now." (Although that can work, there's a good chance that you'll be tasered.) Many people prefer to advertise their goods in the local newspaper in what have come to be known as "personals." It is important when composing a personal ad to lead with your best feature. For instance, you'll want to leave out the fact that you suffer dry skin, especially around your toes, where the flaking can get pretty bad.

Heavyset zoo employee with banana in pocket, seeking mate who loves to swing.

Circus worker, former tomboy, seeks good kisser to help me get my freak on.

Superfly cooly jonesing for a cleopatra w/a sweet, sweet back. Meet for coffy?

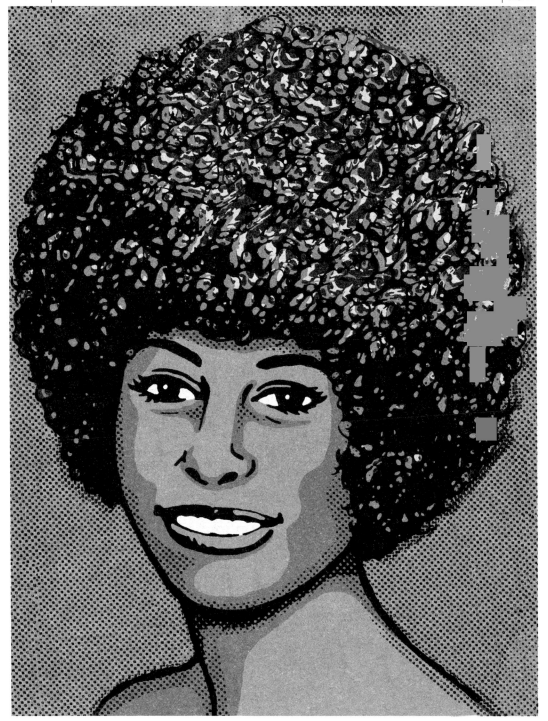

Foxy lady looking for action, jackson. Bring your dyn-o-myte & blow my shaft.

Dungeon Master seeks 5th level Warrior Princess for sexy late-night role-playing.

Peasant personality? Works knights? Royal pain needs geek to do my ebay bidding.

Model RTL-803 seeks any X-series 'bot with whopping 12-prong media port.

Shemalien up for close encounters. Can upload several firmware drives.

Hot-cross buns needed for a steamy plate o' granny's freaky home-cookin'.

Are you a chic chick seeking a sheik? Am I the sleek sikh that you seek?

Blood-sucking ex-wife enjoys late night drinking/meals (no stake, please.)

Me very cromantic. Me like raw meat. You, me go clubbing sometime?

Don't skipper this opportunity! Mary-Ann gingerly seeks first mate for some lovey.

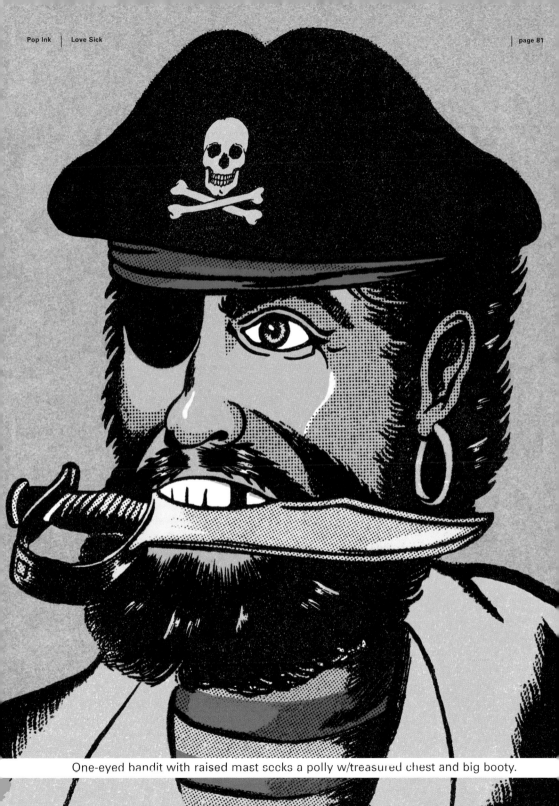

One-eyed bandit with raised mast socks a polly w/treasured chest and big booty.

WHAT'S YOUR SIGN

Astrology has a rich history that goes back to ancient Egypt. It was developed further by the Greeks and found its most profound expression in the '70s, when hairy bachelors in quiana shirts would ooze up to single women, stir their Harvey Wallbangers, and say, "Sagittarius, right? I could tell because I'm Aquarius, and I felt an immediate chemistry between us." (When that failed, the guy would show the woman his Latin Hustle and hope for the best.) Though many dismiss astrology as claptrap and hokum, a recent study concluded that predictions such as, "You may meet an exotic stranger" were correct nearly 14 percent of the time!

CAPRICORN

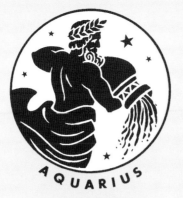

AQUARIUS

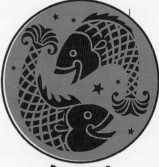

PISCES

ARIES

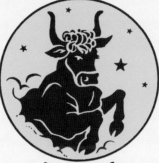

TAURUS

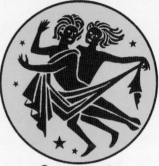

GEMINI

CANCER

LEO

VIRGO

LIBRA

SCORPIO

SAGITTARIUS

AQUARIUS–Today is your lucky day! You will receive a discount on office supplies. Use the savings to purchase a muffin.

ARIES–Love is in the air. Not for you, however. You will spend the evening reading *Maxim* and eating canned tamales over the sink.

LIBRA–Work problems intensify. You will dribble coffee on your Dockers and your favorite highlighter will be stolen by that bastard in HR.

VIRGO–Today is the day to strike! Put up that cat poster you bought last May, or try baking some sort of quick bread. Go, man, go!

GEMINI–Depression is closing in. You have to take immediate steps to stave it off. Barring that, you could end it all. It's up to you.

TAURUS–A small man who smells of burnt cloves will offer you a foreign post position . . . if your name is Ed Malloy. If not, disregard.

SAGITTARIUS–It's not the day to try new things. Danger is in the air. Best lock all your doors and hide under an afghan.

SCORPIO–Your willingness to cooperate will be tested today as a co-worker calls you a "smelly, strange cat turd of a man."

LEO–You will receive a very intriguing phone call today. You won't be in, though, and the caller won't leave a message.

CANCER–A visit to the doctor is in your future, as your steady diet of Arby's Big Montanas finally catches up with you.

CAPRICORN–You will lunch today with a large group and several people will compliment you on your choice of side dish.

PISCES–You will somehow come in contact with water today. It may be in the morning, or possibly afternoon. Definitely by evening.

When approaching a potential mate for the first time, it's best to have a good supply of "pick-up lines." Learn at least a dozen and practice them in the mirror. Try saying things like, "I may not

Do you like raisins? How about a date?

be Fred Flintstone, but I bet I can make your bed rock." Or you could use the honest approach: "My anti-psychotic drugs still make me pretty sweaty, but at least the tremors are starting to subside."

Is that a banana in your pocket or are you just happy to see me?

OFFICE ROMANCE

It's inevitable–when you spend eight hours a day with a large group of like-minded and attractive people of the opposite sex, eventually you will want to get busy with any number of them, often at the same time. But office romances are not without their peril. Get amorous in the stockroom and you could upset the supply cabinet, dumping copy paper, three ring binders, and twenty-four packs of White Out down on top of you, nearly ruining the mood. Sexual harassment laws have also made things difficult. Even a seemingly innocuous remark like "Your sleeves are blue" is now punishable by up to sixty years in prison or voluntary castration.

Computer love

When an office romance flames out and feelings are raw, there can be a loss of productivity as the offended party spends most of her time slashing his tires and leaving dead rodents in his lunch pail.

All the antiquated clichés about boss-secretary relationships—the boss chasing the secretary around the desk, the secretary taking dictation on the boss's lap, the boss wearing her underwear while parading around the office singing "Surrey with the Fringe on Top"—are now things of the past. As women's stature in the corporate world has risen, chauvinistic behavior has nearly vanished. Oh, every now and then, some guy in upper management loses it and ends up pants-less on his desk screaming obscenities, but it's rare.

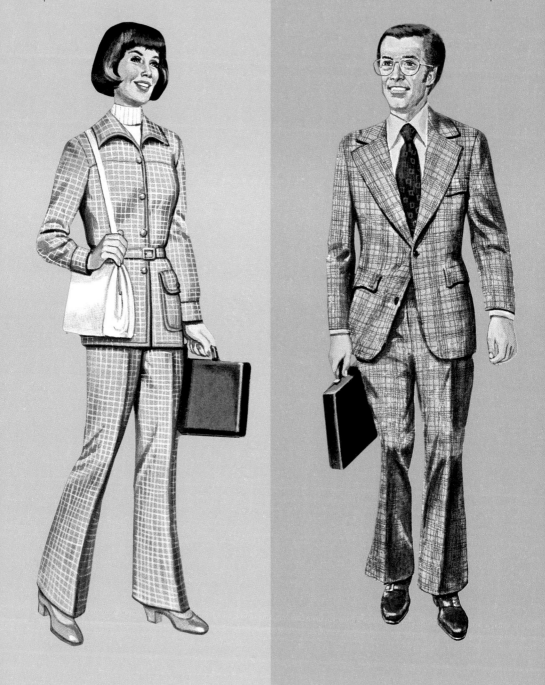

Throwing off the shackles of antiquated social mores, the modern man says, "The old rules don't hold. I'm free now to look like an absolute chump, and my girlfriend/lover is free to look just like me!"

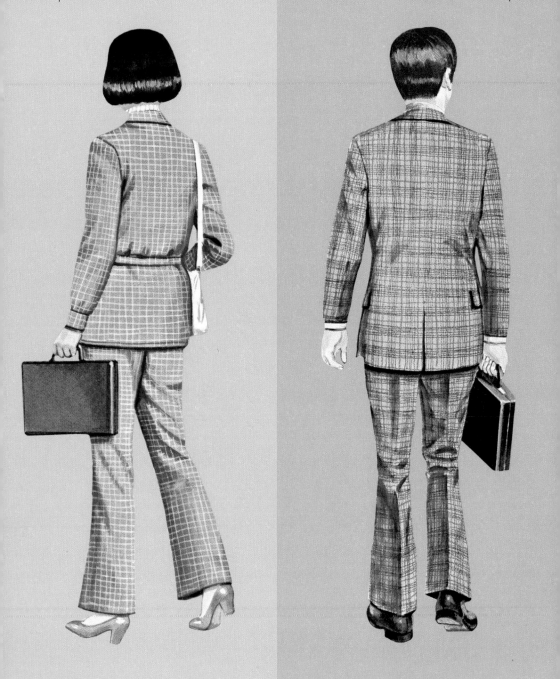

Yes, from the rear, the full horror of it becomes clear; not only do they have similar suits, identical briefcases, corresponding haircuts, and a certain sense of purpose—they have the exact same ass!

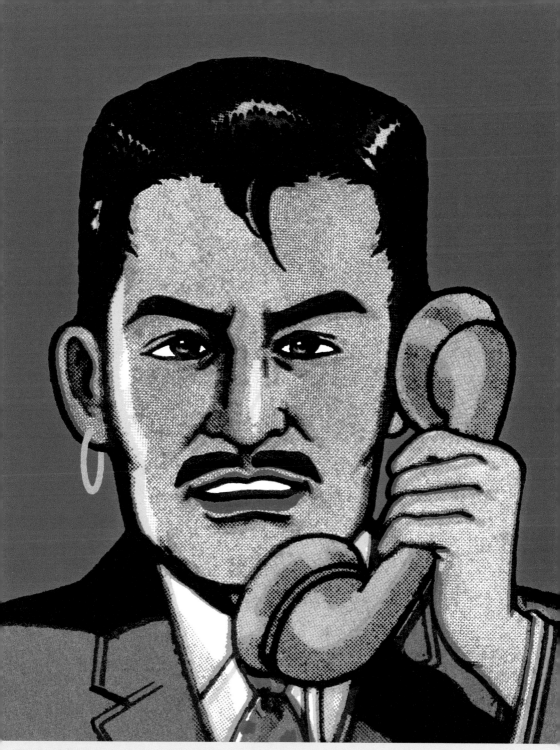

"Darling? Remember when you let me go because I looked too much like Wayne Newton? Well, I've taken some drastic steps to change that. I went and got my ear pierced . . . Hello? Hello?"

SMOKIN'

"Sometimes a cigar is just a cigar," said the great Sigmund Freud, to the delight of all of Europe. (His follow-up *bon mot*, "Sometimes a half-finished jar of brown mustard is just a half-finished jar of brown mustard," was far less enthusiastically received and his reputation suffered.) But the good doctor (a.k.a. The Great Viennese Pervert) was on to something—people too often see phallic symbols where there are no phallic symbols. The Washington Monument, the Eiffel Tower, a penis—none of these are phallic symbols. But the confusion certainly reveals a lot about the minds of people who want to make them that!

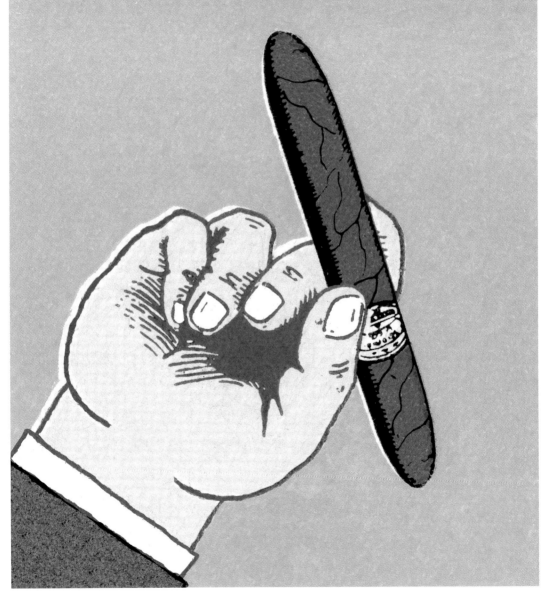

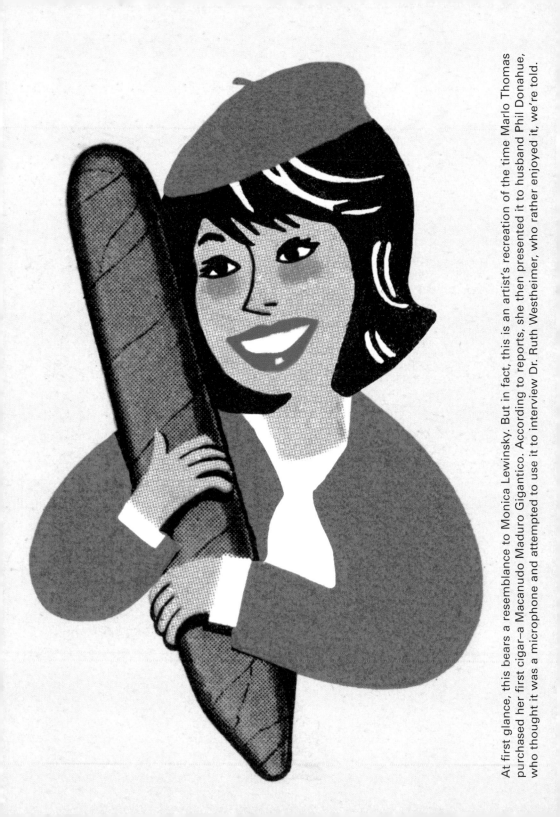

At first glance, this bears a resemblance to Monica Lewinsky. But in fact, this is an artist's recreation of the time Marlo Thomas purchased her first cigar—a Macanudo Maduro Gigantico. According to reports, she then presented it to husband Phil Donahue, who thought it was a microphone and attempted to use it to interview Dr. Ruth Westheimer, who rather enjoyed it, we're told.

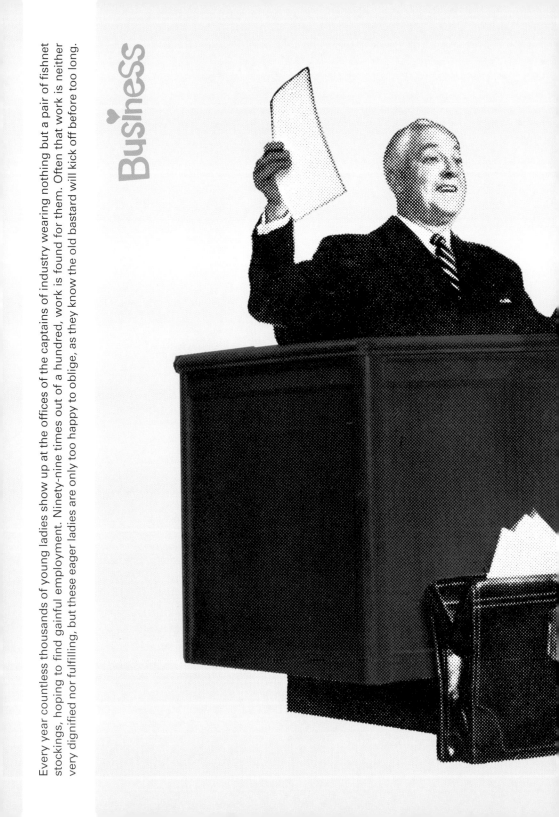

Every year countless thousands of young ladies show up at the offices of the captains of industry wearing nothing but a pair of fishnet stockings, hoping to find gainful employment. Ninety-nine times out of a hundred, work is found for them. Often that work is neither very dignified nor fulfilling, but these eager ladies are only too happy to oblige, as they know the old bastard will kick off before too long.

Business

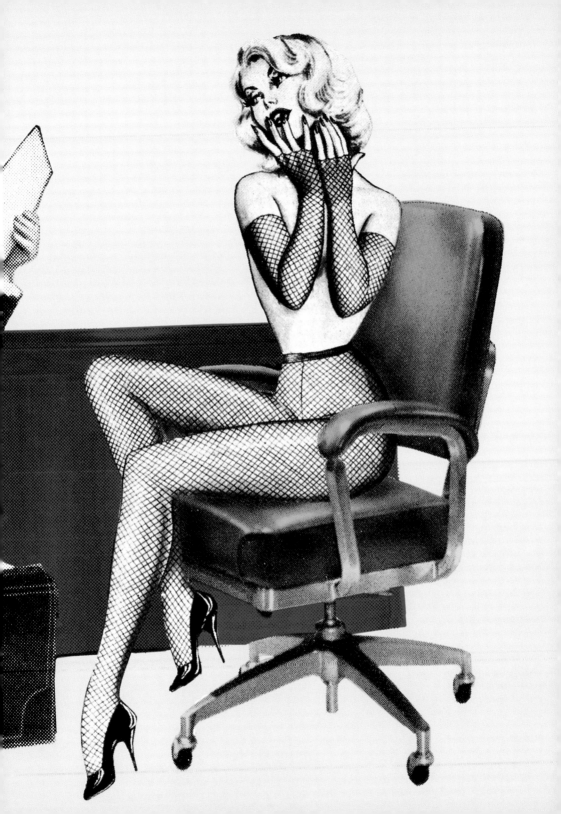

GOLD DIGGER

Why suffer the hardships of earning your own money when you can marry a wealthy septuagenarian dowager with artery trouble? Why? Well, because if you choose the former you are not required to enter the marriage bed with a withered old hag, that's why. However, if you're undeterred, best be prepared. Buy a pallet or two of a good quality nutrition drink such as Ensure or Glucerna. And bring along a little extra money when you visit the Old Country Buffet, as you will not be eligible for the senior coffee discount card. And you might want to start drinking a lot, too.

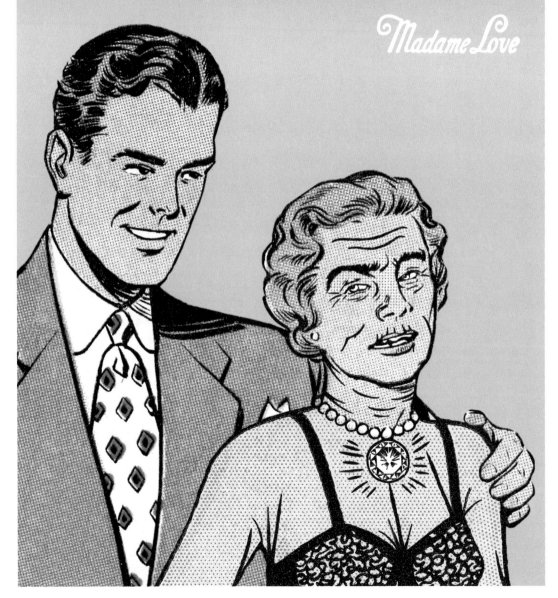

Madame Love

"Yeah, I got pear-cut diamonds coming out the wazoo, so why ain't I happy? You try staring down the business end of that withered old–ah, never mind. Light me up."

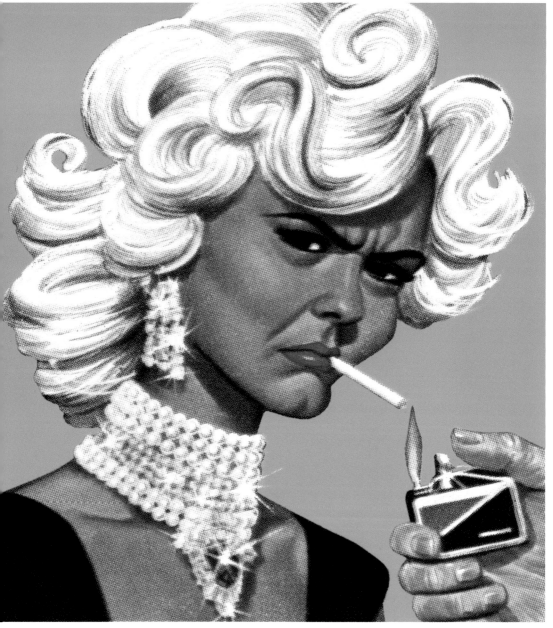

"My husband will be 109 tomorrow and when we're together we're still like a couple of teenagers. That is, I get drunk on wine coolers and he's unable to perform."

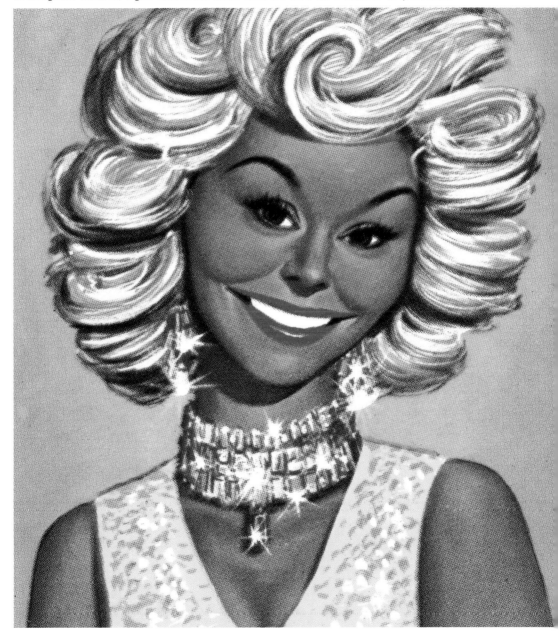

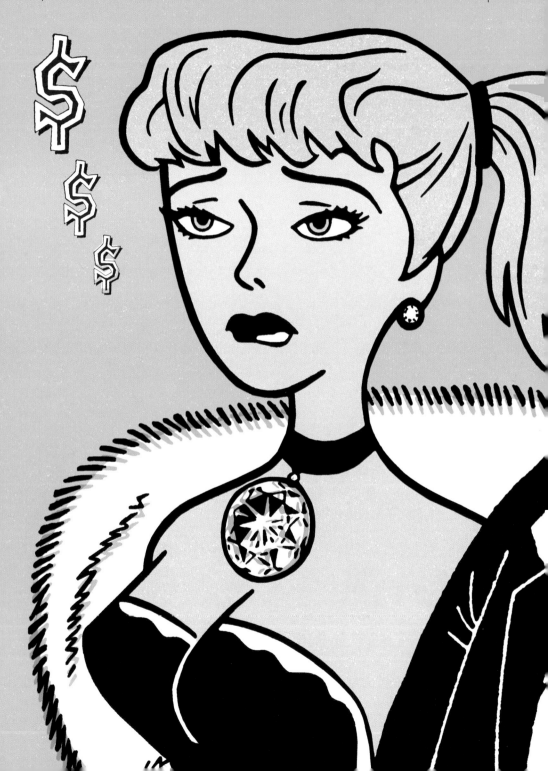

Sometimes plans backfire. Kandi here thought her husband would die twenty-eight years ago, long before the introduction of Viagra. Now he's on his fourth baboon heart, with another donor on deck.

THE KISS

"What is . . . kiss?" So asked the green-skinned alien woman in episode 46 of *Star Trek*. And the green-skinned woman from episode 46 of *Star Trek* ("The Gamesters of Triskelion," in case you're interested) certainly was on to something–besides Kirk, that is. Despite its ubiquity, the kiss is still something of a mystery. Is it the ultimate expression of passion between a loving man and woman, or is it a short and unpleasant experience wherein Stu, the busboy from TGI Friday's, gives you a ride home in his K-car and then attempts to ram his dolphin-like tongue into your mouth while crudely pawing your hair?

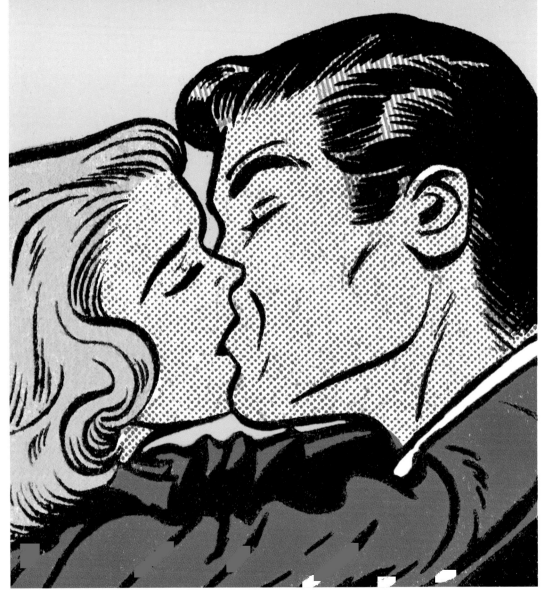

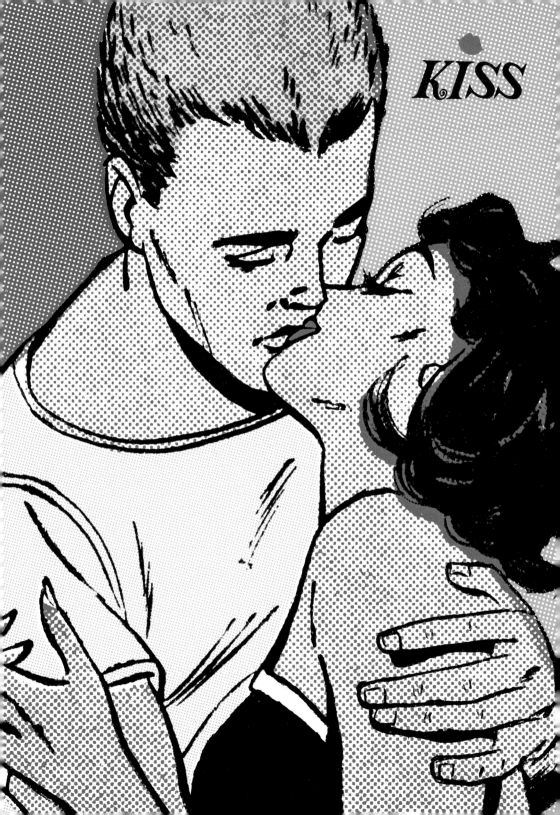

KISS

Many young lovers experience fireworks when first their lips meet. Others experience low-level RPG fire, and the constant shelling from M-252 mortar rounds. Eventually, such explosive experiences diminish and older couples report little more than the quiet fizzing of a damp sparkler.

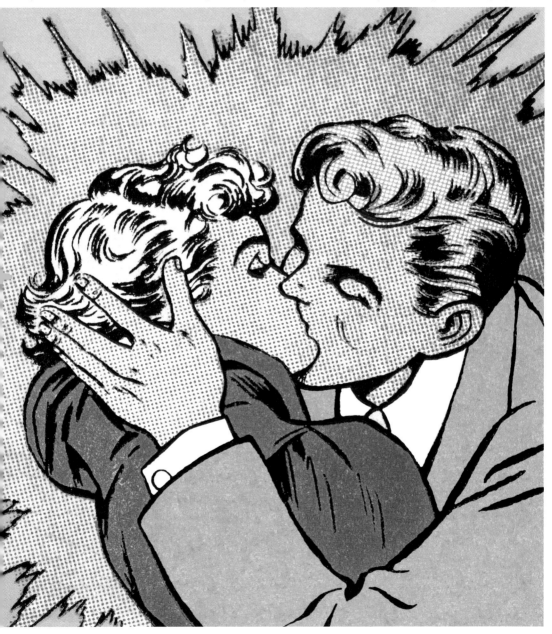

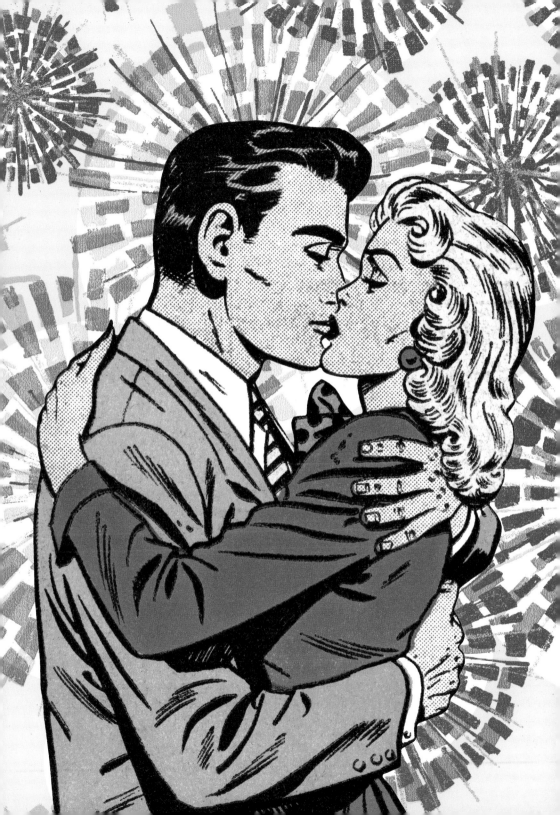

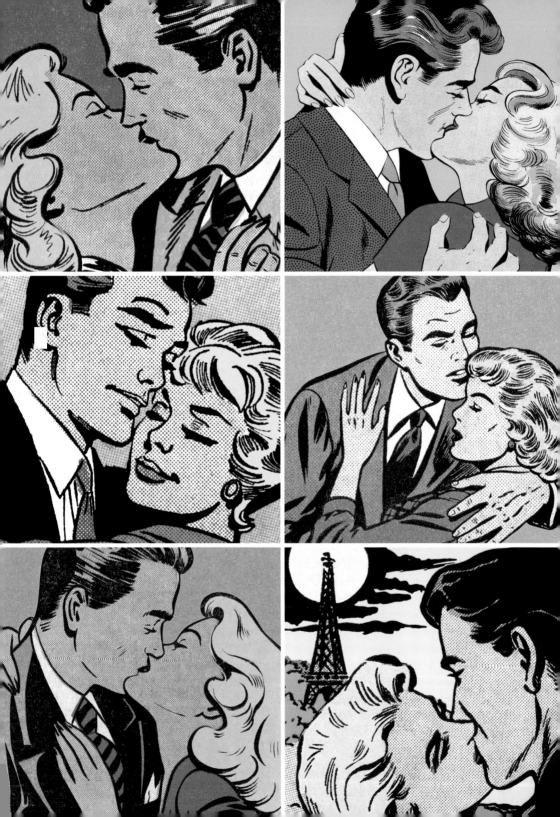

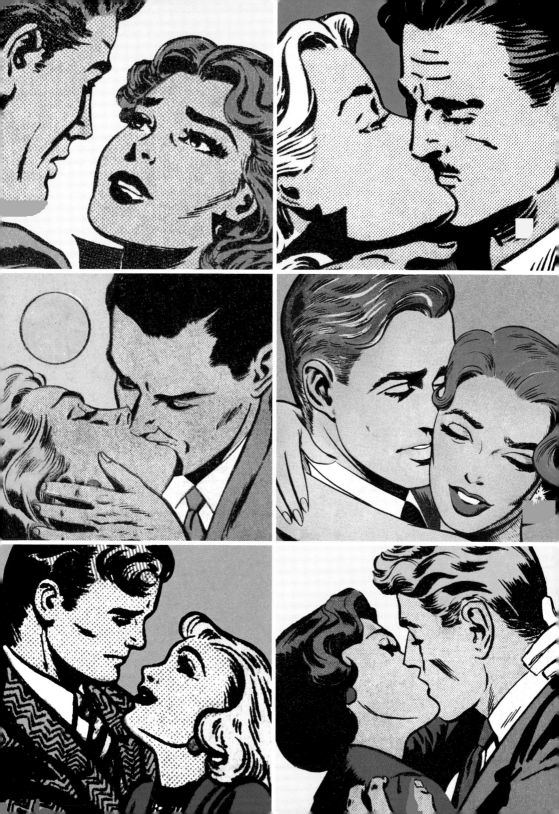

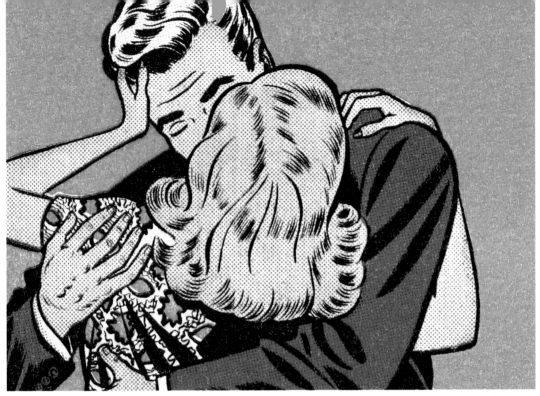

Before kissing the woman of your dreams, here are a few tips to keep in mind: Wild Turkey is in no way an effective mouthwash. Do not use your tongue as a blunt instrument. In fact, do not use it at

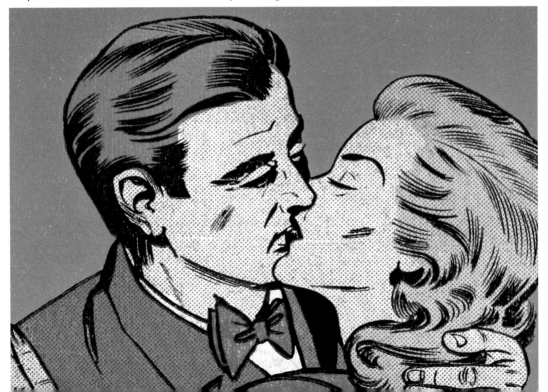

all. It's far less romantic to the girl if, while kissing her, you have your X-Box controller in hand. And, in the middle of a kiss, don't ask, "Okay if I meet Schmitty down at Players for a few brewtowskis?"

JILTED

Nothing in this life compares to the pain of being thrown over by the one you love. Tragically, there is little you can do to ease the pain, short of getting drunk on Boone's Farm Country Kwencher, punching a parking meter till your knuckles bleed, and calling your ex at 4:00 in the morning. Whoever said "It is better to have loved and lost than never to have loved at all" clearly never really loved, or else he loved a really sweaty girl with a mustache who was always trying to give him backrubs in public.

Should you experience the heartbreak of lost love, the best way to deal with it is to lie down and begin weeping uncontrollably for days until your neighbors call the police.

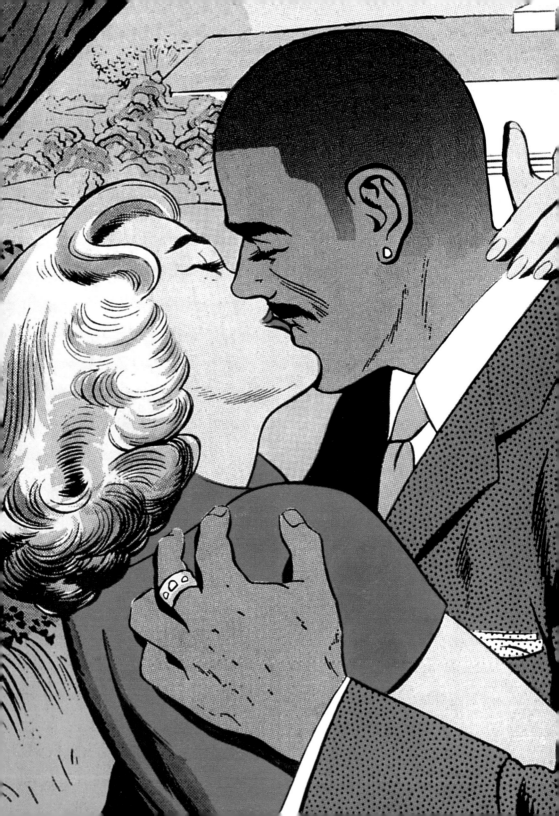

Who among us hasn't left our hobby farm, gone to work at our job at Bledsoe, Bledsoe, Bledsoe, Davidson, and Cole, Attorneys at Law, only to come home and find our wife, Jeanine, in the arms of a swarthy George Michael look-alike? Every single one of us has gone through this—we wouldn't be human if we hadn't. Those who have lived through it successfully know that there is no use crying or complaining: Simply load up the 12 gauge with rock salt, run out of the house screaming like a maniac, and empty a load into the taut backside of the faux George Michael. He won't be prowling around your henhouse anymore.

Scratch the surface of any man and you'll find a fragile, delicate flower within. Gentle tears cloud his eyes upon hearing Streisand's *Broadway Album*; while sipping gently on a General Foods International Coffee French Vanilla Cappuccino, he remarks that Carly Simon only gets better

with age; he wants to hold every baby he sees; when the humidity drops, he begins liberally applying Kiss My Face honey and calendula moisturizing lotion to his combination skin. And women, if you see this delicate flower of a man coming, run. Run, and don't look back.

06-25-05

Dear John,

It is with heavy heart that I take pen in trembling hand to let you know that I have found someone else, and I pray it does not cause you much pain when I tell you that this someone else is actually attractive, has hair, and does not smell like chipped beef. Please believe me when I tell you how difficult it is to unburden myself of the fact that I am dating your second cousin, Lenny, who I met at Dollar Drink Night at Playaz bar over by the mall. Oh, John, how I will miss holding your hand while you tell me unending and painfully dull stories of your work at the Post Office.

Anyway, gotta go,

Jane

SILK STALKERS

Some men have little success being face to face with women, and choose instead to watch them from afar, preferably from across the street as they idle in their '87 Chevy Berettas. Despite the odds against it, many successful love affairs begin this way, though they often end with lengthy federal jail terms and with the woman never having met the man who loves her. Women, if you feel you are being watched, look for these telltale signs: You find the local school janitor hiding in your hedge with cameras, telephoto lenses, and tape recorders. Beware—you may be the target of a stalker!

If you discover that you are being watched, try this simple remedy: Pay a two-bit thug fifty bucks to yank the stalker out of his car and knock him around like a Raggedy Andy doll till he begs for mercy.

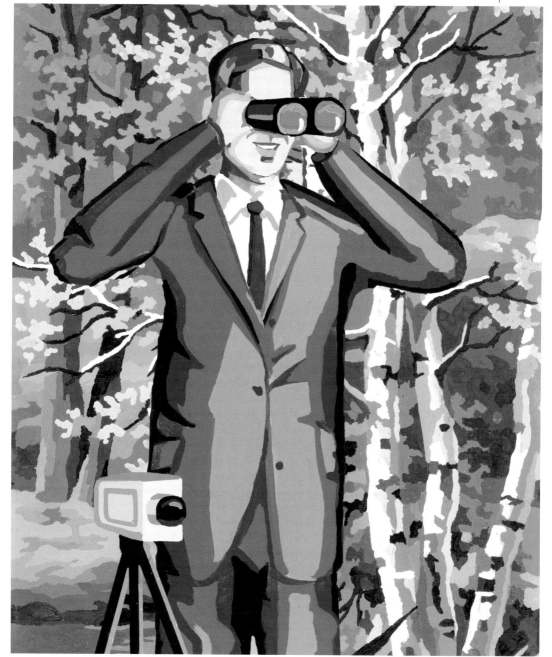

This couple, Ron and Debra Samuelson of Garretsville, OH, have found a way to keep their marriage fresh. Ron pretends to leave for work in the morning, and when he's gone, Debra strips and heads to a local trout stream where she frolics nude on the rocks. Ron then sets up his surveillance gear and watches from a safe distance. At noon, they break for a light lunch of sandwiches and by 12:40 or so, they're back at it. At 5:30, they break for the day and meet back home.

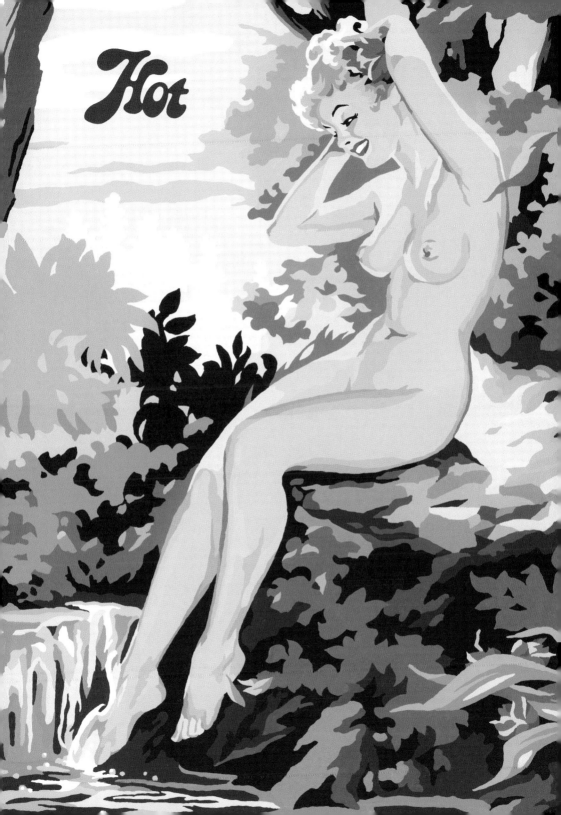

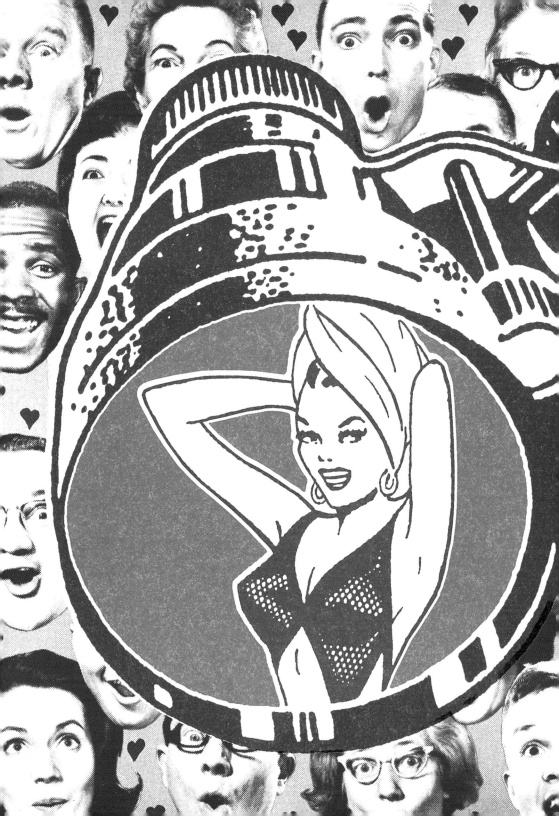

SUPER FREAKY

Buried deep within, we all have a wild side, and, when behind closed doors, we often let it come out and prowl. Take Larry here. When not performing his tasks as the county land assessor or working on his model trains, he enjoys putting on a felt mask and walking around his home. "I don't know why, I just enjoy it. I always felt that there was a felt mask-shaped hole in my life, so I finally said to myself, 'Larry, why not get a felt mask?' And so I bought a good, sturdy mask at Feltmaskwarehouse.com and sewed over the mouth hole. I've never been happier."

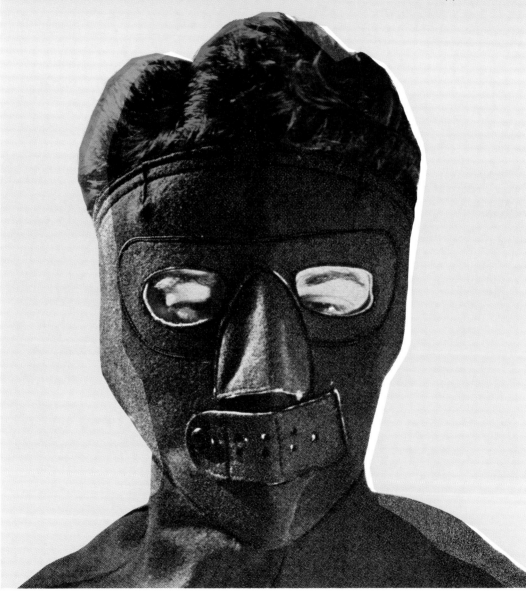

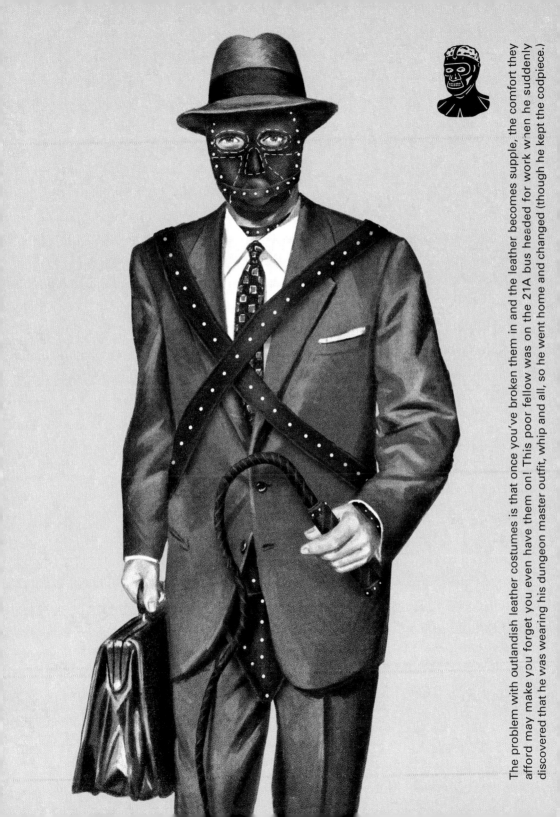

The problem with outlandish leather costumes is that once you've broken them in and the leather becomes supple, the comfort they afford may make you forget you even have them on! This poor fellow was on the 21A bus headed for work when he suddenly discovered that he was wearing his dungeon master outfit, whip and all, so he went home and changed (though he kept the codpiece.)

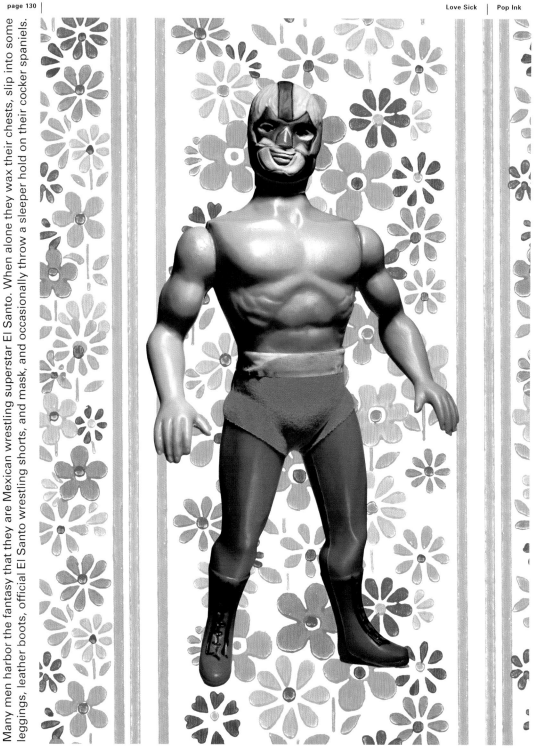

Many men harbor the fantasy that they are Mexican wrestling superstar El Santo. When alone they wax their chests, slip into some leggings, leather boots, official El Santo wrestling shorts, and mask, and occasionally throw a sleeper hold on their cocker spaniels.

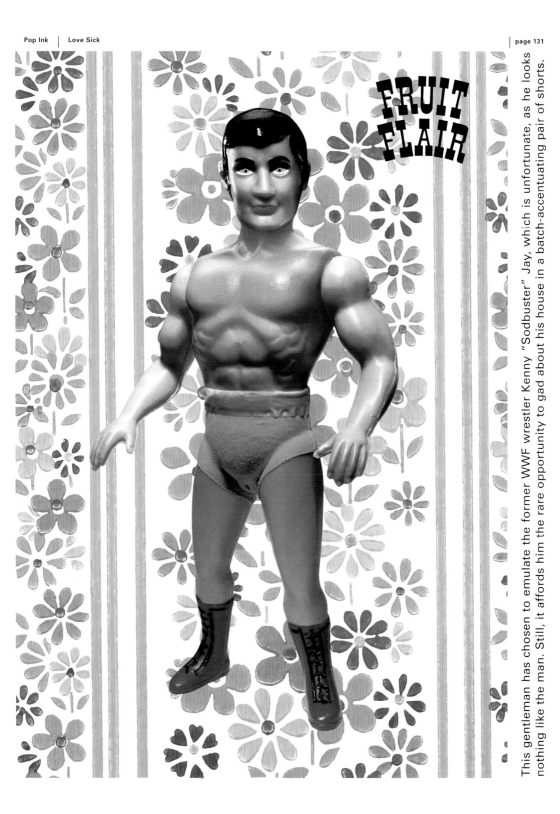

FRUIT FLAIR

This gentleman has chosen to emulate the former WWF wrestler Kenny "Sodbuster" Jay, which is unfortunate, as he looks nothing like the man. Still, it affords him the rare opportunity to gad about his house in a batch-accentuating pair of shorts.

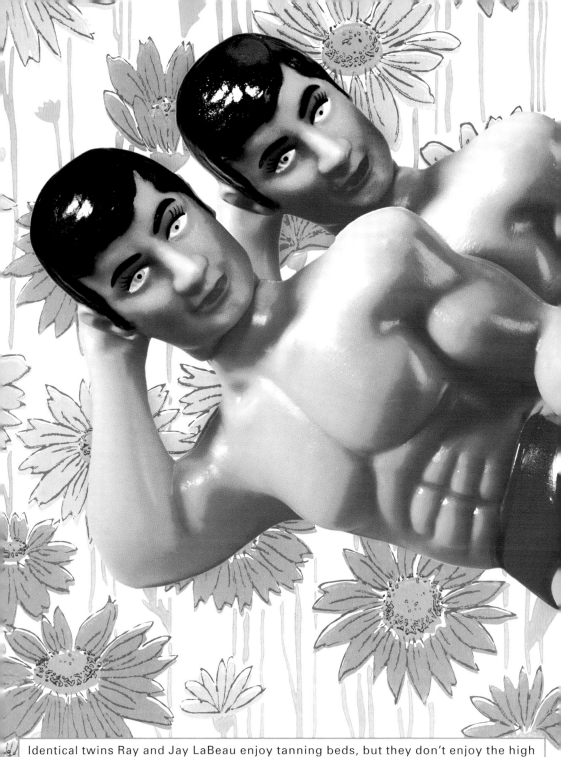

Identical twins Ray and Jay LaBeau enjoy tanning beds, but they don't enjoy the high tanning costs–so they share. Instead of $5.40 an hour, it's–let's see–$2.70 an hour.

"Now that's more like it!" says Ray. Adds Jay, "It's kind of weird, Ray gets really sweaty sometimes and his shorts feel weird against my skin. Otherwise, I love it."

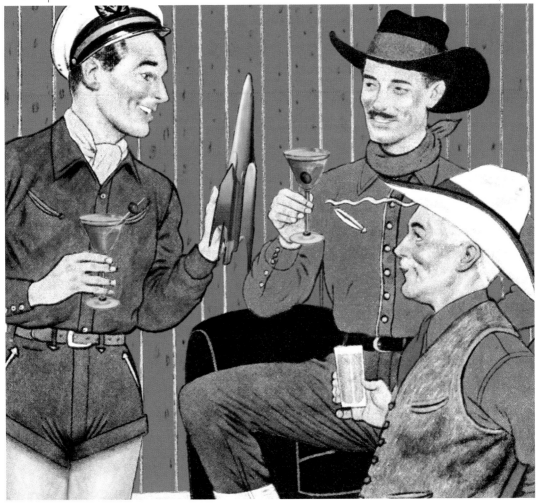

BUCKIN BRONCO

Here's an idea—get together all your guy friends and throw a *Ponderosa* party! You go as Hoss, have your buddy Tom take the part of Adam, and your oldest friend can cover the Lorne Greene role. The problem is Lonnie. That idiot will probably yet again show up in his super-tight belted short shorts and captain's hat, waving that stupid rocket of his around.

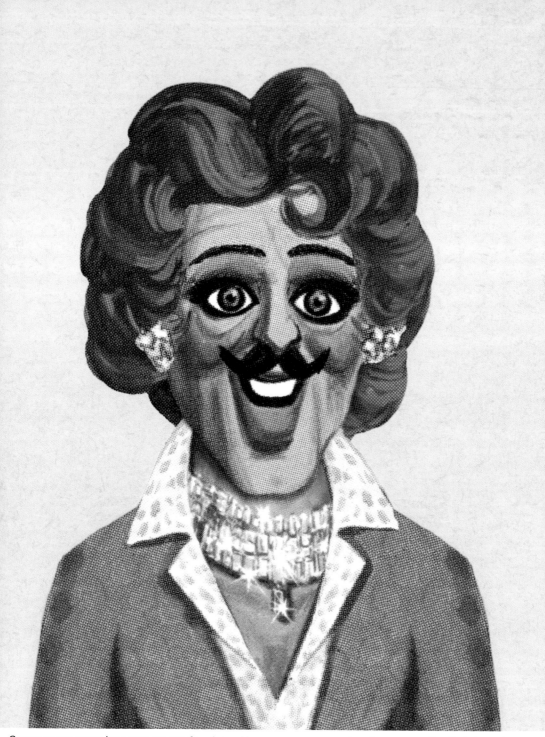

Some guys were just not meant for drag. However, one way to give yourself a fighting chance is to lose the giant cookie duster of a mustache. And don't over-accessorize. It's a dead giveaway.

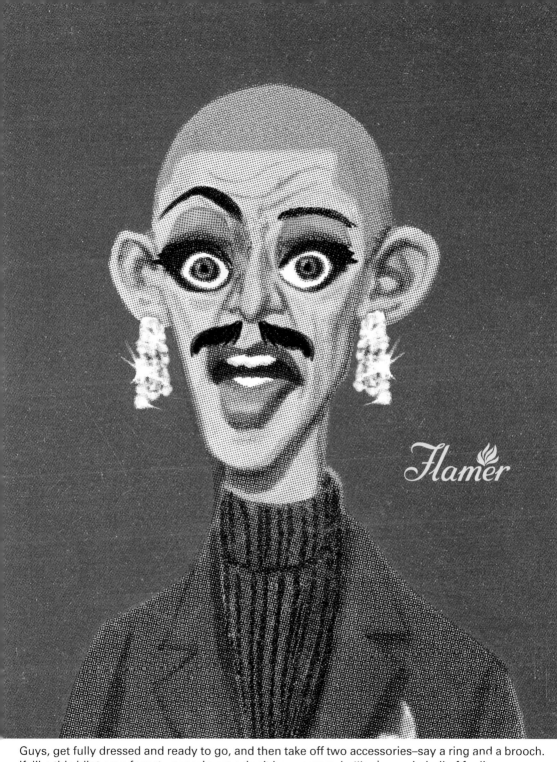

Guys, get fully dressed and ready to go, and then take off two accessories–say a ring and a brooch. If, like this idiot, you forget your wig, you don't have a snowball's chance in hell of fooling anyone.

Guys, if you feel you have nice looking legs, you may want to give the ladies a treat and show them off a little by donning some shorts. There's such a thing as too short, so be careful. I would say that if each step produces more than a few pounds of pressure on your genitalia, it might be a sign to go to the next largest pair. Also, ballet slippers are best left to actual ballerinas.

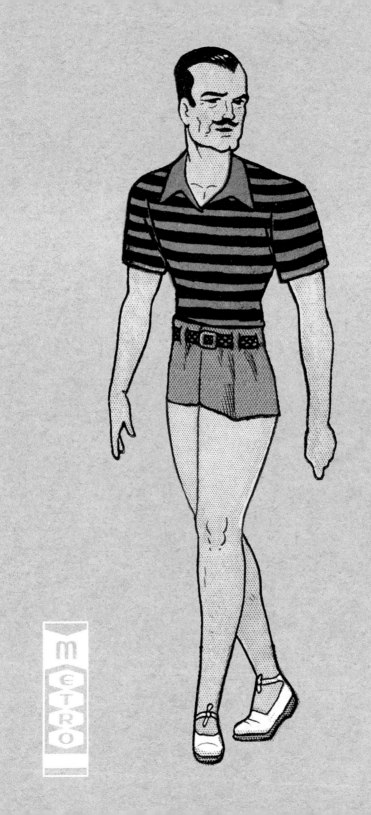

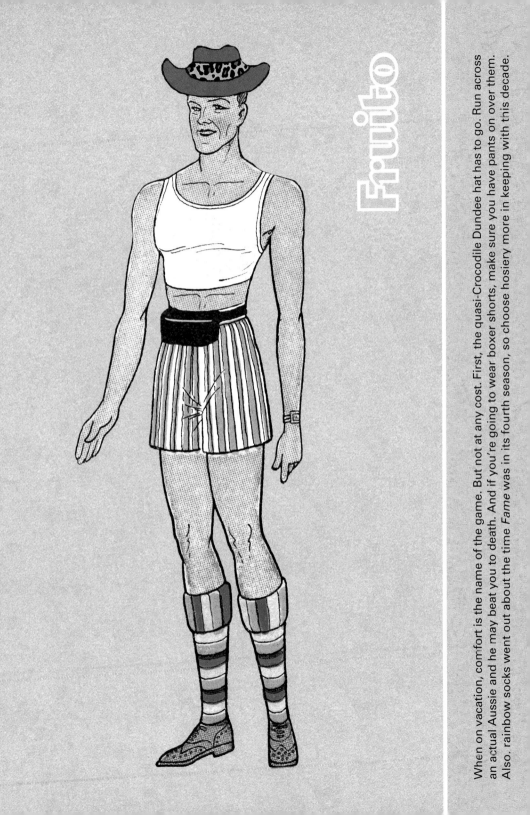

Fruit

When on vacation, comfort is the name of the game. But not at any cost. First, the quasi-Crocodile Dundee hat has to go. Run across an actual Aussie and he may beat you to death. And if you're going to wear boxer shorts, make sure you have pants on over them. Also, rainbow socks went out about the time *Fame* was in its fourth season, so choose hosiery more in keeping with this decade.

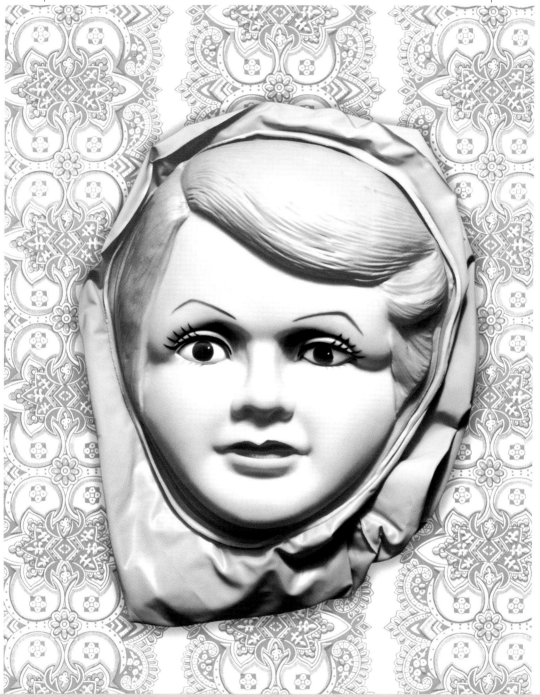

As we go through life, at work and in relationships, with both friends, strangers, and loved ones, we all wear masks. Some of us wear plastic dime-store Sandy Duncan masks, while others

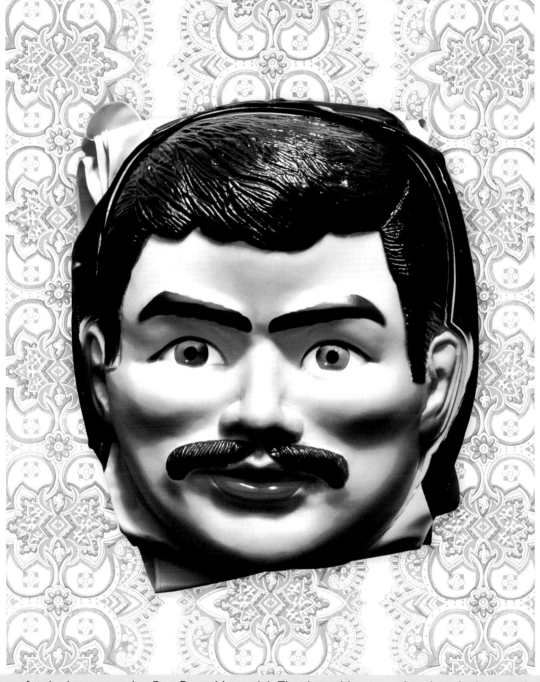

prefer the less expensive Burt Reynolds model. The downside to wearing them is that people don't get to see our true selves, plus they're itchy, and cut down on peripheral vision.

SEX MACHINE

Not every guy is functional straight out of the box, as it were. Some need a little extra help. Dysfunction can often be treated by gearing down the vas deferens, converting the testes to DC power, and boring out the pelvic area to accommodate a turbocharger. If this doesn't work, an external rig can be comfortably installed. These are usually belt-driven and can either be AC, DC, or steam powered. They are quite cumbersome, weighing in at some fifty-eight pounds for the deluxe model, so a belted girdle and reinforced underpants are a requirement. Not that the ladies seem to mind.

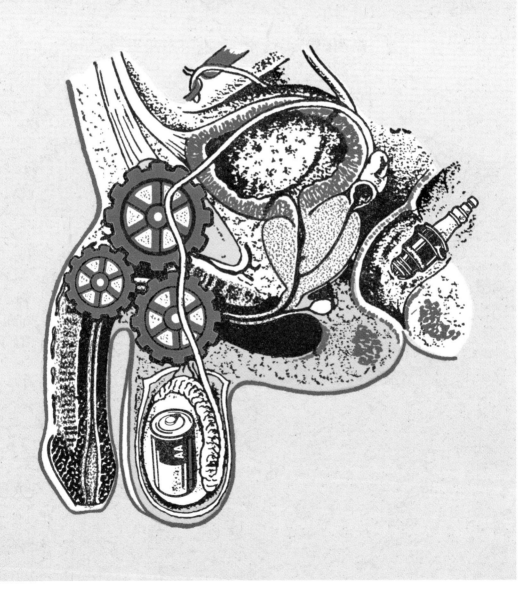

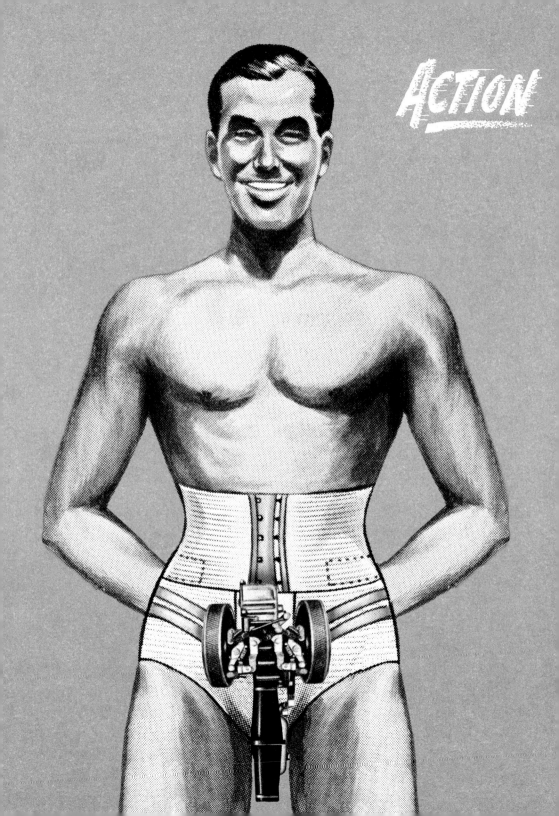

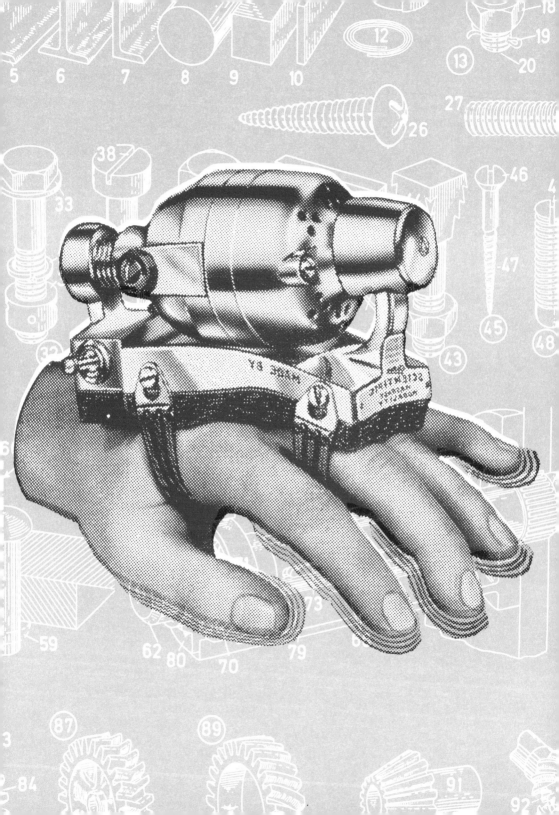

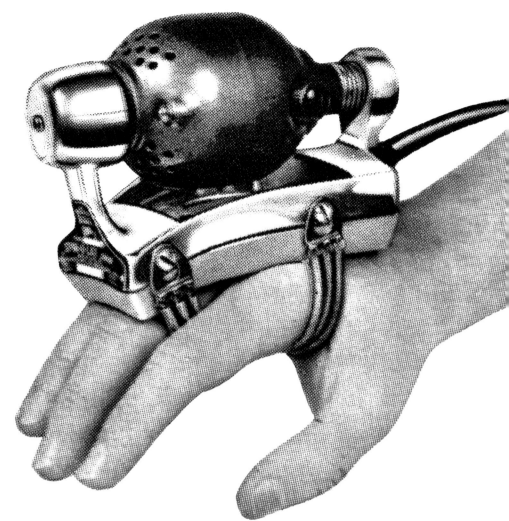

THRILLS

Most people think of the art of massage as a low-tech experience, but the new Ford Motor Company Experimental Massage Division hopes to change all that with their 180-h.p., four-stroke massage assistant known as the Relaxalator 180-XE. It can go from zero to relaxed in 4.6 seconds.

Electricity, carefully controlled, channeled, and regulated, can serve as a powerful relaxant. Though if you are not very careful, it could relax you fully. (That is, you'll be dead.) The Control Master has high-tech safety features in place to minimize as much as possible your death by electrocution. It features a decently legible control knob. That's, um, pretty much it as far as safety features go.

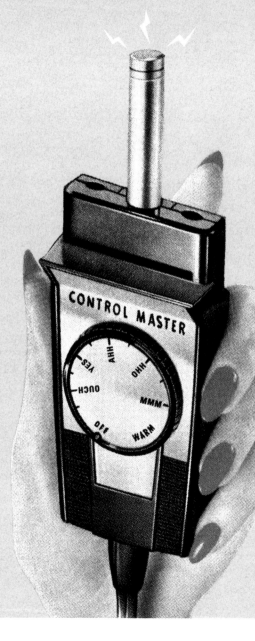

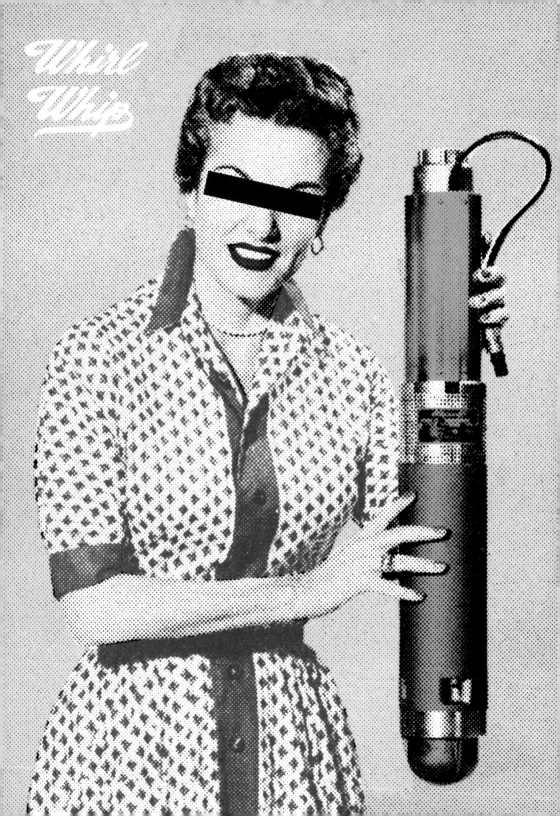

Nothing can relax the jowls quite like a small battery-powered massager shaped like a Japanese cucumber with one end cut off. If, like the woman on the opposite page (who declined to be identified [though I'll just tell you her name is Jane Ryback]), your jowls need even more firepower brought to bear against them, try the hydrogen-powered JR-1500 Xtreme Edition.

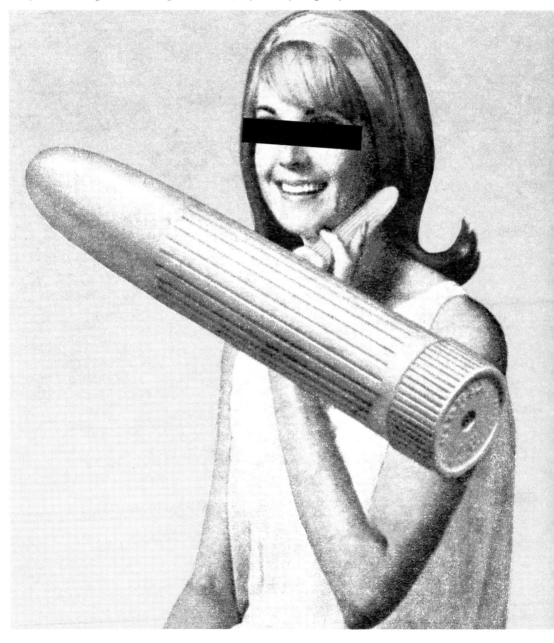

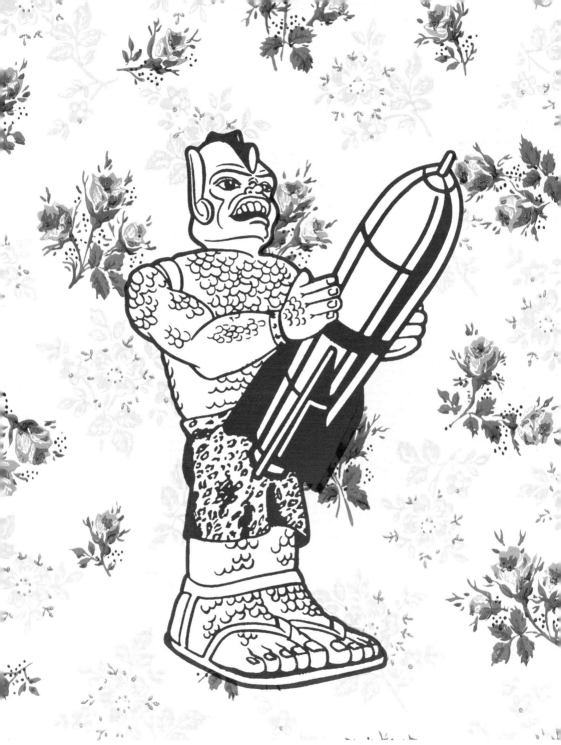

This energetic young sandal-wearing lizard-man is apparently taking the advice of John Kay of Steppenwolf when he advised us to "Fire all of [our] guns at once and explode into space."

Women love rockets. And what's not to love? Tall and impressive, able to carry enormous payloads, the biggest can generate more than 3.3 million pounds of thrust for up to eight minutes. Why, a woman, if she was so inclined, could take a payload and be in orbit within twenty minutes. One caveat: Some rockets fizzle and never make if off the launching pad, collapsing limply back to earth.

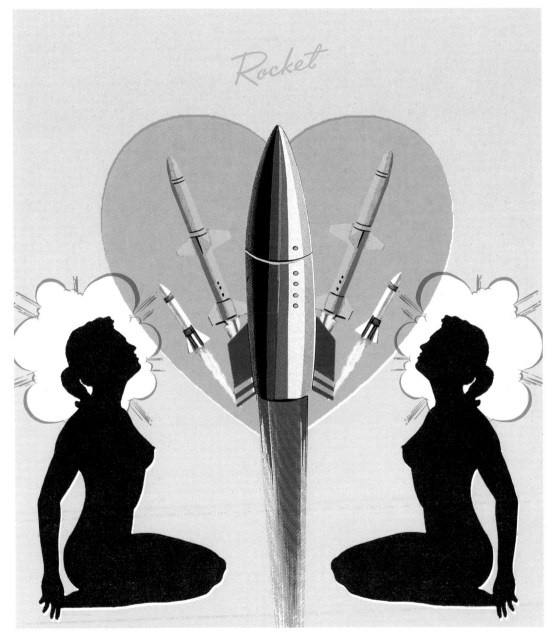

The benefits of bull testicles have been known and written about in some of our most prestigious medical journals for years now and their efficacy is not in dispute. The problem is finding workers willing to harvest the "essence" of the bull testicles. It is difficult, dangerous, and messy work, and the death rate is high. Consequently, most of the essence of bull testicles you find on the market nowadays is actually made in Indonesia from rodent testicles, usually moles or pocket gophers, and is of inferior quality.

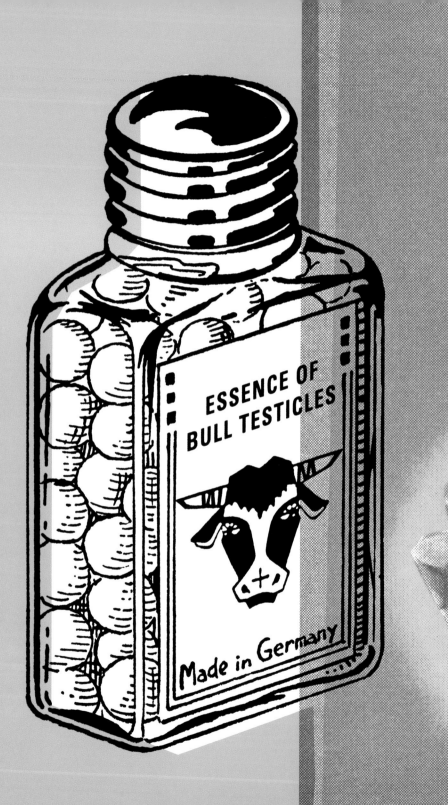

ESSENCE OF
BULL TESTICLES

Made in Germany

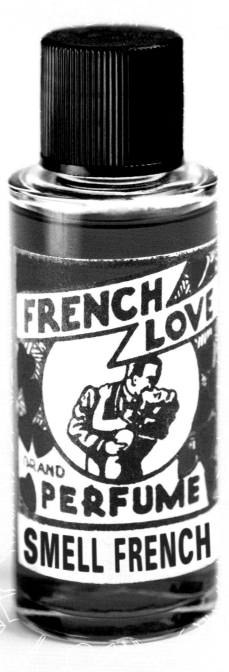

For years you've longed to smell like French love–well, now you can! With French Love Perfume. Think of two lovers strolling down the Boulevard Malesherbes, hands clasped, the music of Edith Piaf wafting gently from the street-side cafes. Well, French love smells nothing

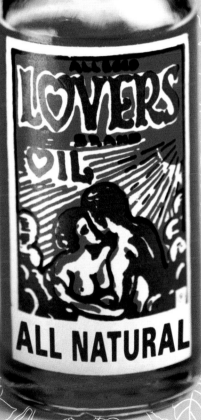

like that. It's kind of musky and stings the nostrils. Perhaps you'd prefer some Lovers Oil, which has excellent ratings for its viscosity and thermal breakdown. You can love on it for up to 6,000 miles–even with aggressive stopping and starting–free from fear of damage to your vital parts.

ON THE ROCKS

Two months' salary: That's what the DeBeers company demands a man spend on an engagement ring for his beloved. That means that if he works part-time at Wendy's and gives away a lot of his shifts so that he doesn't miss *South Park*, he'll end up spending upwards of $98.50–that's gross salary; if you're going by take-home, it's approximately $34.65–on his true love's ring. That's not pocket change. So as not to get fleeced, go to a reputable dealer, preferably one housed in a mall whose food court has at least one Chinese buffet, and that has one or more stores that sell only socks.

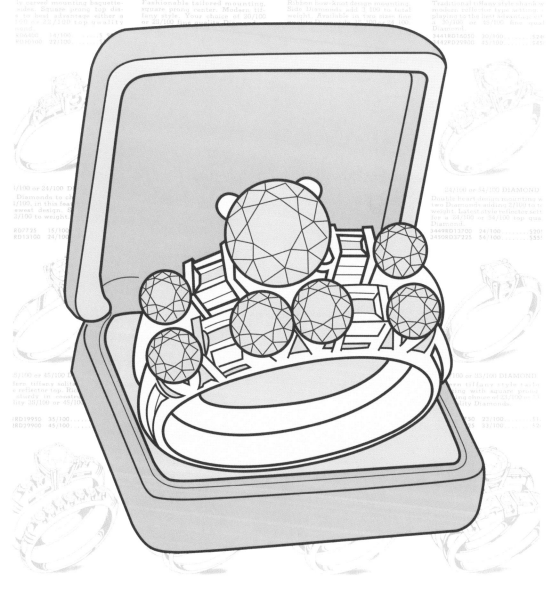

$ High pressure

BIGGEST OF THEM ALL

14 K
TWILIGHT STAR

[A]

AM

NDS S
NO AD

14 K
TWILIGHT STAR

[C]

When purchasing a ring, remember the five Cs: cut, clarity, color, carat, and, let's see, crumbliness, I think. If you press on the edge of the diamond and it crumbles even a little, it's probably a low-quality diamond, and is usually made primarily from mucilage or expired hardware store epoxy. The other four Cs are relatively unimportant next to the ring's crumbliness.

Though traditionally men buy their wives rings on an anniversary, there's no reason at all not to give your wife a huge rock on, say, October 9, which is Leif Erikson Day, or December 23, Feast of the Radishes Day. If you do, you can then participate in the many Radish Day feasts, and when your wife is distracted, steal the ring back and get a refund.

Clean your diamond regularly to restore its clarity and brilliance and to remove all the built-up skin oil, dander, and congealed sebaceous discharges.

Ideal Cut

Less Than Ideal Cut

Shoddy Cut

Crew Cut

Hurry-Up Cut

Disgraced Princess Cut

Cutting a diamond for ultimate sparkle and brilliance is an art that requires years of schooling, a sharp eye, and a steady hand. In fact, if you are considering getting into the business, don't even bother. Go to your local trade school and learn refrigeration instead.

Unripe Pear Cut

Mall Cut

Mistake Cut

BALL AND CHAIN

A wedding. The coming together of a man and woman to make one; the holy joining of two souls under the eyes and blessing of God; a chance for your cousin Barry to drink too many Captain 'n' Cokes and try to kiss your brother's wife before peeling out in his Impala and smashing it into a light pole right in front of the police station. More than anything, though, a wedding symbolizes the absolute obliteration of a man's freedom, the crushing of his carefree spirit, the beginning of a life of skull-crushing monotony, the bloody slaughter of his independence, and the beginning of an iron-booted rule where once there was autonomy. The cake is pretty, though.

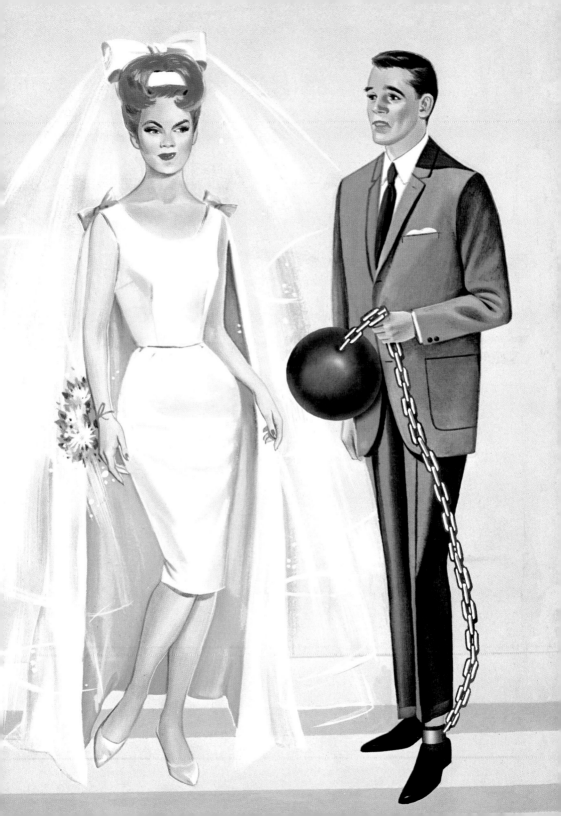

Traditionally, a white wedding dress symbolizes purity, fidelity and chastity. Tomato-colored pantsuits symbolize mild affection and a generous dose of marital reluctance. This guy's double-breasted suit with the thirty-six-inch wide lapels symbolizes his inability to purchase something new for his own damn wedding, showing a decided lack of enthusiasm for the whole venture.

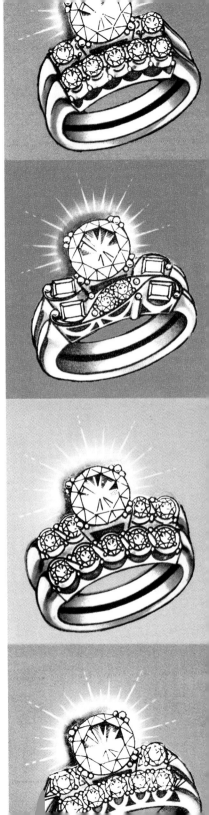

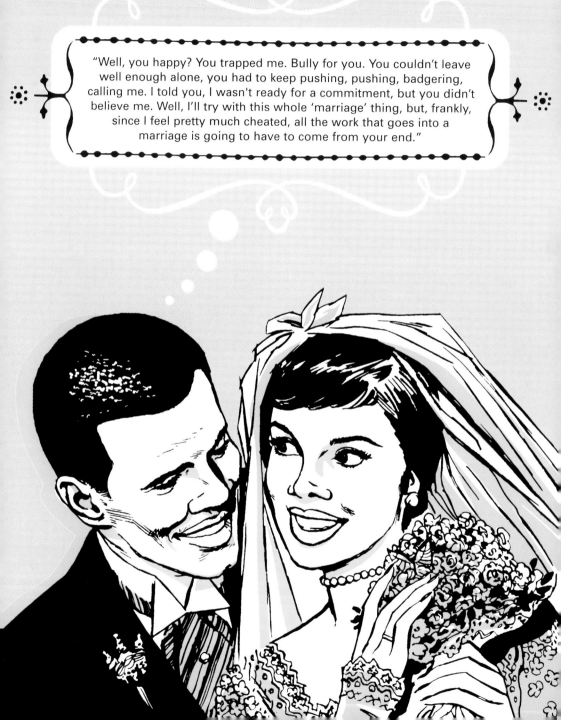

This is Gloria. She's just so darn happy she married Hal that she can't stop smiling. She also laughs a lot in strange, inappropriate ways. I think this marriage may have pushed her over the edge.

Hal is smiling because Gloria signed his pre-nup with almost no questions asked. And it's a rail-road job, I'm tellin' you what. She'll be selling pretzels out on the street when this thing is over.

When selecting a cake, choose one that is firm to the touch but doesn't have any soft spots. Turn it over in your hands, look for the stem end, press gently, and then smell. It should smell sweet, not moldy. Hang on–that's how to choose a melon. I have no idea how to choose a cake. I imagine you'd just try to find one that goes well with cheap keg beer.

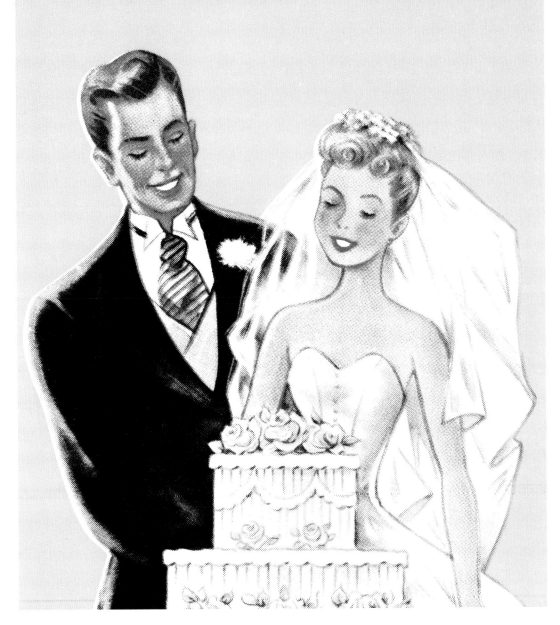

Marriage, for all its blessings, can really play hell on the human body. You start out fresh and happy, blushing with pride; you end up a broken shell, your soul as brittle and empty as a discarded bird's nest, your body beaten down and nearly worthless. Oh, you can attempt to keep the harsh reality